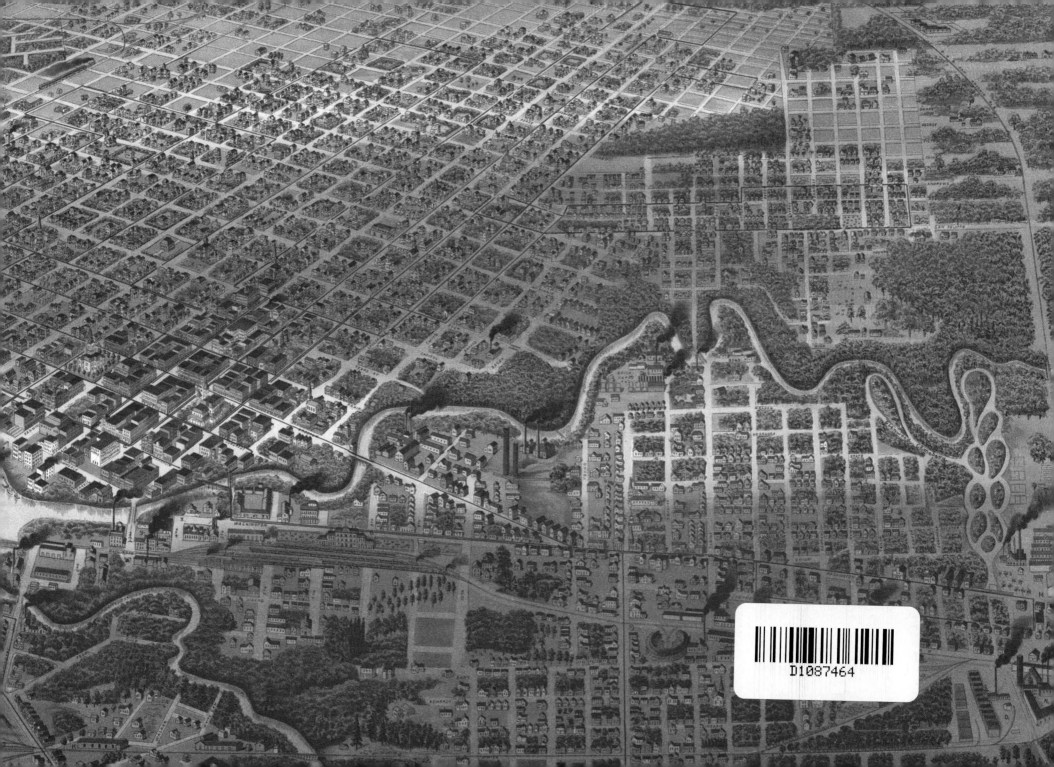

D1087464

THE STORY OF BUFFALO BAYOU PARK

THE STORY

of

BUFFALO BAYOU PARK

CONTENTS

FOREWORD

AS THE TITLE OF THIS BOOK ASSERTS, WHAT IS SO REMARKABLE ABOUT THE TRANSFORMATION OF BUFFALO BAYOU PARK IS THAT IN OCTOBER 2015, IT HAPPENED!

BY

STEPHEN FOX

Buffalo Bayou Park—expanded, enhanced, and extraordinary—is now used by a broad array of Houstonians and visitors. It is admired, indeed loved, by an appreciative and growing public. And this transformation took only a hundred years to achieve.

In historical perspective, a century is often the real time frame in which substantive change occurs in cities. A hundred or more years ago, Houston was a city of 80,000 people, the third largest in Texas. It was only in 1899 that Houston acquired its first public park, Sam Houston Park on the east bank of Buffalo Bayou. By 1910, Houston was home to people who thought big and, inspired by the civic vision of the nationwide Progressive Movement, harbored great ambitions for their city. The Houston Ship Channel, Rice University, Hermann Park, Houston Symphony, and the Museum of Fine Arts, Houston, were among the most notable sites and institutions founded during this period. What distinguished early twentieth-century Houstonians from their early twenty-first-century successors was a lack of intimidation at the prospect of planning for the future. In terms of civic vision, they turned to the young Cambridge, Massachusetts, landscape architect and city planner Arthur Coleman Comey and the St. Louis landscape architect and city planner George E. Kessler to analyze Houston's potential and extrapolate a big picture of the future.

The few surviving Kessler drawings relating to Houston include one labeled "Outline Map of Houston Showing Park Properties." This drawing illustrates property in Fourth and Sixth Wards on the north and south banks of Buffalo Bayou labeled "Exposition Ground," a westward extension of Sam Houston Park, and Cleveland Park farther west, on the north bank of the bayou. Straight lines indicated at least the prospect (if not necessarily the exact alignment) of future parkway drives alongside Buffalo Bayou.

Mobilizing these schematic suggestions and bringing them to life required the exuberant philanthropic vision of Will C. Hogg, the Houston lawyer, real estate developer, and art collector who adopted the planning of Houston as his civic cause in the 1920s. With his sister Ima and their brother Mike, Will Hogg acquired the 1,503-acre pine forest on the north bank of Buffalo Bayou—the approximate location of the proposed park site that Arthur Comey called Pines Park in his 1913 report. Hogg and his siblings conveyed this parcel to the City of Houston in 1924 to become Memorial Park. This transaction marked Will Hogg's first big foray into city planning and public philanthropy. During the mid-1920s, Hogg bought property between Hermann Square and Sam Houston Park on the southwest edge of downtown to become the site of the Civic Center. In 1924, Hogg Brothers, the family management firm, assembled 700 acres along Buffalo Bayou south of Memorial Park to become

River Oaks Country Club Estates, which Will Hogg intended as a model for how the rest of Houston could develop into an intelligently planned, environmentally responsible, and beautiful modern city. Hogg also financed the acquisition of property that enabled the City of Houston to construct its first linear bayou parkway, Buffalo Drive (now Allen Parkway), along the south bank of Buffalo Bayou in 1925–26. Allen Parkway was the model for the White Oak Bayou and Brays Bayou parkways that were developed between the 1920s and 1960s.

The combination of public planning vision and philanthropic generosity, and the systematic integration of open space, mobility, recreation, and nature, continue to shape and reshape Buffalo Bayou Park. The transformation of the corridor under the guidance of Buffalo Bayou Partnership, with the extraordinary support of the Kinder Foundation, demonstrates the advantages that public spaces in the heart of Houston provide. Today, Buffalo Bayou Park features a pastoral landscape incorporating existing and newly planted native and adaptable vegetation. The park renovation project pays tribute to the environmental stewardship of Ima Hogg, Terry Tarlton Hershey, George Mitchell, George H.W. Bush, and Frank C. Smith Jr., who in the 1960s prevented the U.S. Army Corps of Engineers from concreting the channel of Buffalo Bayou as had occurred on Brays Bayou and White Oak Bayou. It

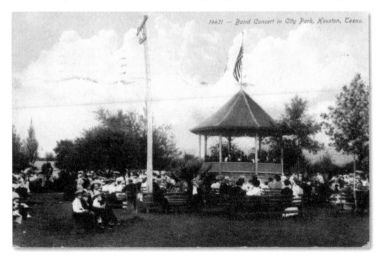

also builds on the environmental vision of architect and landscape architect Charles Tapley, who in 1974 produced a long-term plan for reclaiming Buffalo Bayou Park to make it more accessible. The bayou's frontage in Memorial Park has experienced minimal engineering interventions. There you can see the tall clay bluffs and root networks of the old-growth riparian forest lining the bayou's north bank. In contrast, the banks in Buffalo Bayou Park have been re-channeled and re-profiled, cleared of existing vegetation and extensively laid back to construct wide stepped terraces to better accommodate and detain such massive floods as those of May 1, 2015, and April 18, 2016. Sudden, catastrophic flooding is a natural circumstance that SWA Group, the landscape architects responsible for the design of Buffalo Bayou Park, had to anticipate, leading to what Scott McCready of SWA describes as a design ethos of resiliency so that the park can quickly recover from the destruction inflicted by rapidly rising, swiftly moving flood water. Balancing natural unpredictability with the public accommodations required to bring large numbers of people into the park was the crucial conundrum upon which SWA's design had to pivot.

In March 2016, the Washington D.C.–based Cultural Landscape Foundation sponsored a two-day symposium in Houston focusing on the design of local public spaces, both completed and envisioned. Along with Hermann Park and Discovery Green, Buffalo Bayou Park was presented as evidence that, as the foundation's founder and president, Charles A. Birnbaum, asserted: "Houston is undergoing a monumental landscape-architecture-led transformation whose scale and impact could fundamentally change the city and influence city-shaping around the globe." Reflecting on the cycles of change that have shaped and reshaped Buffalo Bayou Park, architect Guy Hagstette, project manager for the Buffalo Bayou Park transformation, observed: "Plans have true power, even if they take more than a century to be realized." What Buffalo Bayou Park teaches us is that public spaces, like the natural systems they contain, are dynamic, responsive, and evolving. Plans, with their vision of fixed order, may seem irrelevant to such natural fluidity. But plans provide the critical blueprint for human consensus and action, and serve in the long term as historical documents that can continue to inspire and motivate, even after a hundred years.

Stephen Fox is an architectural historian and a Fellow of the Anchorage Foundation of Texas.

ORIGINS
A 1907 postcard commemorates a band concert in City Park, now called Sam Houston Park.

HISTORICALLY, WE'RE IN AN UNPARALLELED PERIOD RIGHT NOW IN THE ATTENTION BEING PAID TO URBAN RIVERS ... HOUSTON IS VERY MUCH IN THE LEAD IN THIS, AND ITS PROJECTS ARE SO LARGE-SCALE AND AMBITIOUS [THAT] YOU CAN ONLY COMPARE THEM TO THE PLANNING IN THE NINETEENTH CENTURY, WHEN CITIES FIRST ESTABLISHED THEIR PARK SYSTEMS.

ADRIAN BENEPE, director of city park development at The Trust for Public Land

GLENWOOD
CEM

HOUSTON

1922 topographic
map of Houston
showing the ravines,
gullies, and tributaries
along Buffalo Bayou.

ACKNOWLEDGMENTS

Buffalo Bayou Partnership offers a heartfelt thank you to the individuals, organizations, and entities that shared their talents, thoughts, insights, and expertise for the making of this book. We greatly appreciate the contributions of all who served as sources and consultants in weaving together the story of Buffalo Bayou Park.

From Rendering to Reality: The Story of Buffalo Bayou Park was generously underwritten by the Kinder Foundation.

Thank you to our editorial team composed of Sandra Cook, Stephen Fox, Kathleen Hart, Sylvana Loc, Leigh McBurnett, Claudia Morlan, Anne Olson, Trudi Smith, and David Theis, as well as the team at Pentagram Design/Austin. A special note of thanks to Houston historian Louis Aulbach, whose interviews and book *Buffalo Bayou: An Echo of Houston's Wilderness Beginnings* were helpful references.

Thanks to our principal park photographers Jim Olive and Katya Horner, along with additional photographers Zahid Alibhi, Jenny Antill, Nash Baker, ShauLin Hon, Geoff Lyon, Peter Molick, David Norton, Karen Sachar, Jonnu Singleton, and Brian Swett.

We extend our gratitude to every person, plant, and animal, even Mother Nature herself for their contributions to Buffalo Bayou Park and to this book. We hope you relish this account of the park's journey *From Rendering to Reality*.

PREFACE

In spring 2014, as major improvements at Buffalo Bayou Park were underway and the renovated park had begun to take shape, an overwhelming number of positive reactions began flowing in from local and national sources. This tremendous response inspired Buffalo Bayou Partnership, the Kinder Foundation, and others to produce this book that showcases all the ideas and efforts that went into the realization of the renewed park.

From private funding to the collaboration of the City of Houston, Harris County Flood Control District, and other entities, along with the coordinated efforts of multiple architecture and landscape architecture firms and nature conservation groups, the entire park project was a complex and concerted effort that has produced truly remarkable results within the parameters of the park and across the city.

From Rendering to Reality: The Story of Buffalo Bayou Park reveals more than 100 years of civic vision for Buffalo Bayou just west of downtown Houston and highlights the numerous park plans set forth by city officials, noted architects, and urban planners over time. The book recounts how early twentieth-century plans preceded the acclaimed 2002 visionary plan *Buffalo Bayou and Beyond* steered by Boston-based Thompson Design Group.

The book also features hundreds of spectacular photographs of Buffalo Bayou Park, historical images, and maps, along with fascinating insights into the thoughtful design and engineering efforts behind the park's success. The pages highlight the greenspace's enriched native landscape and wildlife habitat, its wide range of trail improvements, the creative lunar cycle lighting scheme, the multi-faceted destinations and their architectural considerations, plus major public art installations.

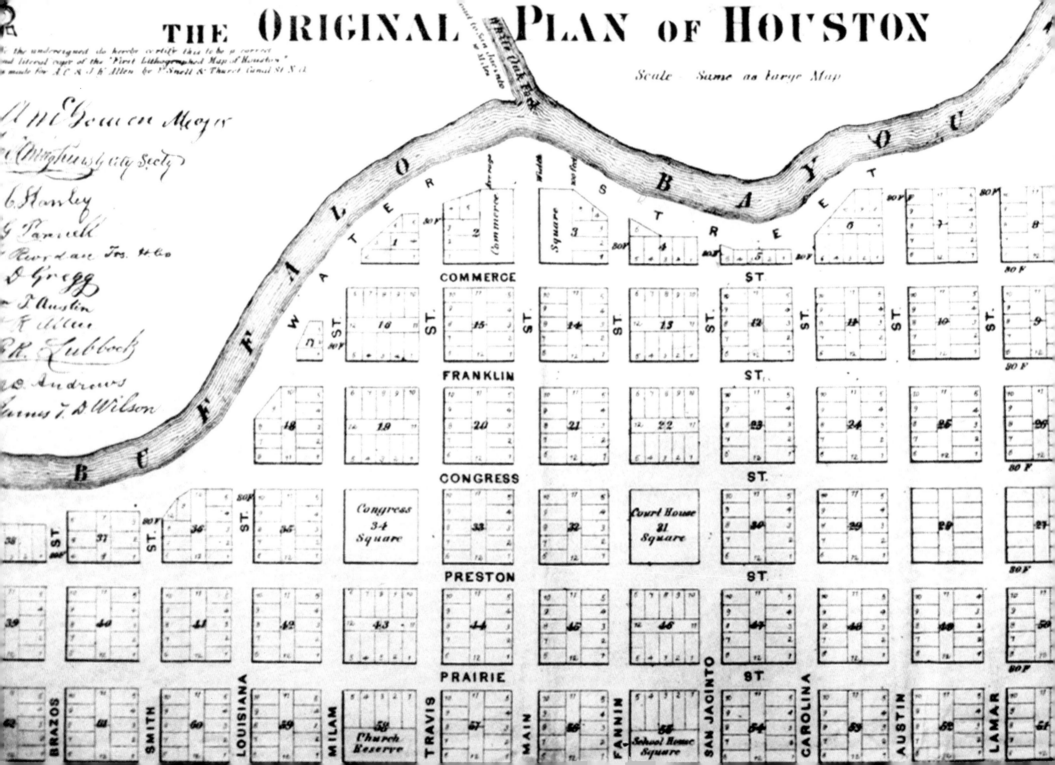

THE ORIGINAL PLAN OF HOUSTON

Scale Same as large Map

COMMERCE ST.

FRANKLIN ST.

CONGRESS ST.

Congress
34
Square

Court House
31
Square

PRESTON ST.

PRAIRIE

ST.

Church
Reserve

School House
Square

BRAZOS SMITH LOUISIANA MILAM TRAVIS MAIN FANNIN SAN JACINTO CAROLINA AUSTIN LAMAR

PART 1

BUFFALO BAYOU

THE WATERWAY THAT SHAPED HOUSTON

ORIGINS
The Allen brothers'
original plan of
Houston.

Today, Buffalo Bayou Park is a renowned Houston landmark and destination, but to fully appreciate the park and its significance, it is important to consider the relationship between Buffalo Bayou and Houston throughout the city's history.

There are a number of possibilities for the origin of Buffalo Bayou's name. Perhaps it was named for the bison, which Spanish explorer Álvar Núñez Cabeza de Vaca took note of during the 1530s. Another possible inspiration might be the "buffalo fish," which once swam these waters. But one thing is certain: Buffalo Bayou launched the city of Houston.

After the Texian victory at San Jacinto and subsequent Texan independence, New York real estate speculators John and Augustus Allen wanted to found a city on a navigable, commerce-friendly stream that would connect the Texas interior to Galveston Bay. That stream would have to include a basin large enough to allow ships to turn around and head back to Galveston after taking on their loads of cotton and lumber. The Allens first tried to ac-

quire the remains of Harrisburg—recently burned by Santa Anna—where Buffalo Bayou and Brays Bayou meet, but town founder John Harris' estate was tangled in probate after his death.

So the speculators pushed farther inland, to the junction of Buffalo and White Oak bayous. There, at the site now known as Allen's Landing, they scrambled out of their ship, purchased the land from a settler family for $5,000, and began drawing up their city.

The Allens predicted that Houston would grow into greatness. In their famous advertisement of 1837, they wrote: "Nature appears to have designated this place for the future seat of government."

In 1828, visitor J.C. Clopper described Buffalo Bayou as "the most remarkable stream I have ever seen … its meanderings and beautiful curvatures seem to have been directed by a taste far too exquisite for human attainment." Clopper also noted the variety of trees: "Flowering magnolias; oak trees draped with Spanish moss; river birch, bay, sweet gum, sycamore, hickory

and walnut trees; American holly and yaupon, covered with red berries in the winter; and hawthorn, viburnum and the white-blossomed dogwood in the spring."

Above all, the Allens had made a practical choice. Houston was situated in a "well-located," "well-watered," and even "salubrious" place, they audaciously wrote. It was a location that would inevitably be home to the "great commercial emporium of Texas," as predicted by their largely fictional advertisement.

But the fledgling city's grandeur still lay far in the future. An early settler and future governor, Francis R. Lubbock, wrote about his journey inland from Galveston in 1837 on the steamboat *Laura*, during which he and his crew overshot the "city" of Houston because there was so little sign of civilization along the banks of Buffalo Bayou. After getting stuck in the brush along White Oak Bayou, they had to turn around and look very carefully for signs of settlement.

Before long, however, the city became easier to find. It grew quickly along the bayou banks, as if Houston itself were part of the lush nature that surrounded it. An 1837 visitor described the boomtown as "not only the center of most of the spirit and enterprise of Texas, but … the focus of immigration from all directions."

Even after the Texas capitol was moved from Houston to Austin, the city grew in accordance with the Allen brothers' vision. Mills, a foundry, and brickyards appeared, along with small factories and, surprisingly, a book-binder. These businesses, plus an impressive number of bars, "pleasure houses," and even the occasional church, all grew within steps of Allen's Landing.

But the bayou and its banks that lay to the west of Houston, where Buffalo Bayou Park is today, had a less urban function. Houston historian Louis Aulbach reasons that the land to the west of the city quickly became the area's farmland and the source of Houston's food because it was higher and less swampy. Aulbach mentions that downtown's Preston Avenue Bridge (now Mosbacher Bridge) on what was then the western edge of the city, would see "400 oxcarts a day" cross it as farmers brought their crops to Market Square. Just beyond the bayou's banks were area ranches, including the 30-acre spread belonging to Sam Houston at what is now Dallas and Taft streets.

Aulbach maintains that for years many Houstonians had forgotten how intimate and important the relationship is between Buffalo Bayou and Houston. In the early decades, Buffalo Bayou was a major part of everyday life in Houston—and thankfully it is once again.

① *A rare snowfall at Allen's Landing looking south down Main Street, taken during the 1920s.*

② *The sternwheeler St. Clair loading at the foot of Main Street, late 1800s.*

③ *The steamboat Lizzie loading cotton near Main Street, approximately 1873.*

Besides providing food, the area that is now Buffalo Bayou Park was also a recreational destination for late nineteenth-century and early twentieth-century Houstonians. They plunged into the swimming hole formed by Shepherd's Dam, canoed on Vick's Lake near Waugh Drive, and picnicked under the abundant native trees. Thanks to thoughtful redevelopment, Buffalo Bayou Park is once again a name on Houston maps.

ONE HUNDRED YEARS OF PURSUING THE CITY BEAUTIFUL

Today, residents do not farm the banks of Buffalo Bayou Park, but like early Houstonians, locals and visitors can once again enjoy its natural charms. Houstonians now flock to the park to run, walk, and bicycle through its floodplain and paddle on its waters.

Houston has been called an "amnesiac city," one that has little time or use for the past. But in a very real way, the redevelopment of Buffalo Bayou Park allowed Houston to reclaim this area for some of its earliest uses. Thanks to recent landscaping efforts and renewed interest in native plantings, the area has regained a semblance of its original appearance. Perhaps J.C. Clopper would be pleased to see the return of the greenery that made such a strong impression in 1828: flowering magnolias, oaks, sweet gum, sycamore, and bald cypress, among others.

Inspiration and efforts to enhance the general area surrounding Buffalo Bayou Park date back to the early twentieth century. Houston's legacy of public planning and civic beautification efforts unfolded as a relay race of sorts, with numerous city leaders and architects making progress toward the finish line in fits and starts for more than one hundred years.

During its early years, the city grew from what is now downtown toward the west, with development hugging both banks of Buffalo Bayou. German immigrant communities formed between Washington Street (now Washington Avenue) and the waterway, and also in the Fourth Ward, south of the bayou, where freed slaves established Freedmen's Town after the Civil War.

From the 1830s through the 1870s, this attractive area also became the final resting place of deceased Houstonians, as City Cemetery (now Founder's Memorial Park, 1836), Beth Israel Cemetery (1844), and eventually

①

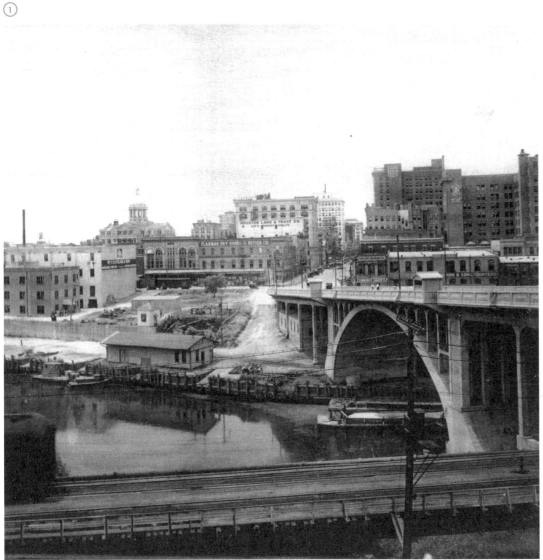

②

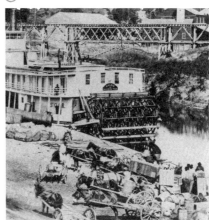

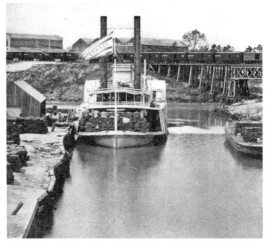

③

1924–25
Hare & Hare produce studies for the Civic Center and a bayou parkway, leads to creation of Buffalo Drive (now Allen Parkway) and Memorial Drive

1927–28
Gulf Publishing, Starr Engraving, and other buildings built along Allen Parkway

1929
May: Worst flood in Houston's history takes a major toll on park area • *October:* Great Depression impacts Civic Center vision

1930s
Jefferson Davis Hospital, Houston Housing Authority complex, and DePelchin Faith Home built in the area

1939–45
World War II

MID 1940s
1929 citywide parks plan revised, plans for Memorial Drive extended west

LATE 1940s
Renewed public interest in the development of Buffalo Bayou parkway

1950s
Aesthetics and natural ecosystem of the parkway and bayou are diminished by the Waugh Drive cloverleaf intersection and flood control measures

1950s AND 60s
City of Houston fails to follow the plan for locating new Civic Center buildings along Buffalo Bayou • The City neglects to provide open spaces or landscaping in the area

1960
Civic Center expanded to include the present-day Theater District

1962–65
Buffalo Bayou Park area becomes focal point as American General complex, Allen House apartments, Holiday Inn, and Fonde Recreation Center built near bayou

1966
Corps of Engineers' plan to line Buffalo Bayou with concrete prevented thanks to efforts of Terry Hershey, George Mitchell, Frank Smith, and Congressman George H.W. Bush

1972
The Wortham Foundation funds and builds the first system of trails along the bayou

1978
The Wortham Foundation donates and installs the Gus S. Wortham Memorial Fountain

MID–LATE 1970s
Charles Tapley spurs conservation in the area by accentuating a natural tributary within the park • Tapley draws up similar plans for the entire Buffalo Bayou Park area

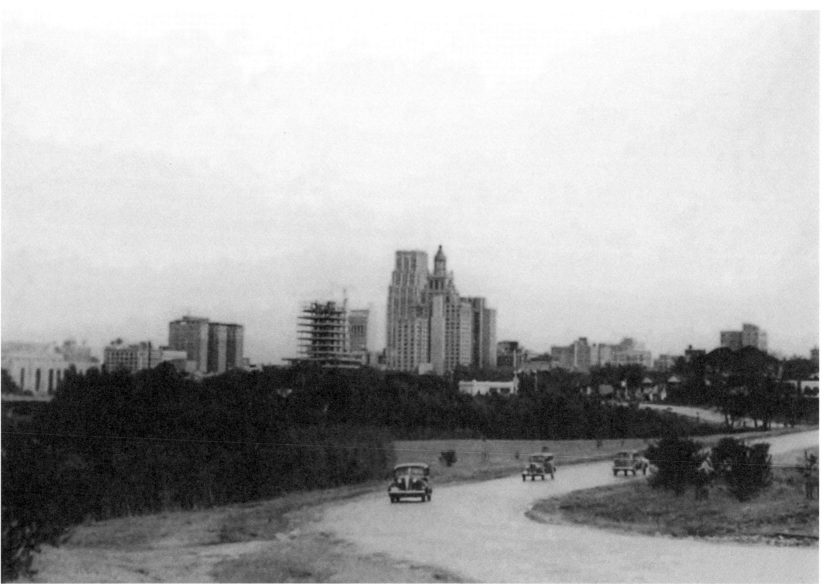

Glenwood Cemetery (1871) were created. Other cemeteries followed, often serving specific communities, such as Beth Yeshurun Cemetery in 1891.

Over the ensuing decades, the area became industrialized. Several brickyards opened to take advantage of clay along the bayou's banks. The Houston and San Antonio Railway ran through the area, and Houston's first oil industry—cotton oil production—also took root. Working-class neighborhoods sprang up near the bayou.

By the 1880s and 1890s, citizens began calling for city parks. City Park (later renamed Sam Houston Park) was founded in 1899. Featuring the city's first zoo, the park immediately saw heavy use, leading both city leaders and citizens to call for more greenspace. The City began acquiring more land for potential park use, and in 1910, Mayor Horace Baldwin Rice appointed a Board of Park Commissioners who recommended a "park circle" around the city that would join Buffalo and White Oak bayous with landscaped boulevards.

The board retained noted landscape architect Arthur Coleman Comey to develop a park plan. He argued that "the backbone of a park system for Houston will naturally be its bayou or creek valleys, which readily lend themselves to 'parking' … All the bayous should be parked except where utilized for commerce." Comey also recommended that the city officials establish a civic center near Buffalo Bayou that would include important public buildings.

Mayor Rice championed Comey's ideas, and in his annual report of 1912 urged future administrations to create a large park along Buffalo Bayou "that will for all time be of sufficient magnitude for our people."

In 1914, however, George Hermann bequeathed land for a major park, and focus shifted to the area that is now Hermann Park, near the Texas Medical Center. At the same time, the Board of Park Commissioners appointed famed landscape architect George E. Kessler as consulting architect. Kessler attempted to implement Comey's many recommendations; however, the plans were not adequately funded.

The demands of World War I and the retirement of Mayor Ben Campbell, a parks proponent, slowed the City's efforts, but in the early 1920s, park development returned to the forefront. In 1922, Mayor Oscar Holcombe appointed a City Planning Commission, which eventually recommended a zoning ordinance, a civic center, and plans for beautifying the bayous. After the death of Kessler in 1923, the city retained prominent architecture firm Hare & Hare to carry out his unfinished proposals.

A PARK PLAN
Landscape architect Arthur Coleman Comey's park plan, early 1900s.

Park development along Buffalo Bayou was reignited in 1924, when the Hogg siblings, Will, Mike, and Ima, offered 1,500 undeveloped acres to the City at a low cost. These acres, consisting mostly of pine forest, would become Memorial Park. At the same time, Will and Mike Hogg developed the widely admired River Oaks neighborhood, in part to demonstrate the advantages of civic planning. In 1927, Mayor Holcombe appointed Will Hogg to chair the City Planning Commission, where Hogg and others began implementing parts of Hare & Hare/Kessler proposals. They built part of the Civic Center, including the public library (now the Julia Ideson Building) and administration buildings around Hermann Square, and remodeled Sam Houston Park. At the same time, impressive buildings, such as the Gulf Publishing Building (now demolished) and Starr Engraving Building (now home to Houston Arts Alliance and Stages Repertory Theatre), were developed along Buffalo Bayou.

BUFFALO BAYOU PARTNERSHIP

- **1986** Buffalo Bayou Partnership founded under Central Houston
- **1989** Sesquicentennial Park Phase I completed
- **1995** BBP's land acquisition program begins (east of downtown)
- **1997** Allen's Landing Phase I opens
- **1998** Sesquicentennial Park Phase II completed
- **2001** Allen's Landing Phase II opens
- **2002** *Buffalo Bayou and Beyond* Master Plan completed • Sunset Coffee Building acquired • Skimmer Boat cleanup program begins
- **2003** Buffalo Bayou east sector trail construction begins • Bayou Buddies young professionals group created
- **2004** Buffalo Bend Nature Park in Houston's East End land acquired

ADMIRERS CALL HERSHEY "A FORCE OF NATURE," WHILE SHE WRYLY REFERRED TO HERSELF AS A "PHILOSOPHER HOUSEWIFE."

TERRY HERSHEY

NATURE AND WILDLIFE ADVOCATE

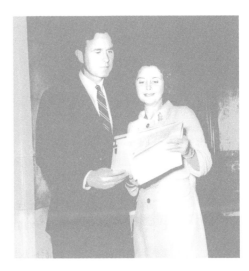

Born Therese Tarlton in Fort Worth, Texas, the late Terry Hershey moved to Houston in the 1950s when she married Jake Hershey. When the Hersheys were not sailing in international yacht races, Terry Hershey took part in local Junior League and garden club activities. She found her true calling in the mid-1960s when she discovered that the U.S. Army Corps of Engineers had begun leveling trees and straightening a stretch of Buffalo Bayou. She was outraged at both the destruction of natural habitat and the lack of public input.

Hershey, along with oilman and bayou preservation activist George Mitchell and Frank C. Smith Jr., rallied public opinion and met with then-new Congressman George H.W. Bush to request his help in removing federal funding for the project. Deeply impressed by Hershey, Bush asked her to testify before Congress. Not only was the funding withdrawn and the project eventually cancelled, but federal rules for approving such projects were changed to allow more citizen input.

Hershey's long career as a nature and wildlife advocate was just getting started. She was an early member of the Buffalo Bayou Preservation Association, now the Bayou Preservation Association, and one of the organizers of Citizens Who Care, which later became the Citizens' Environmental Coalition. She also helped create The Park People Inc. organization to push for more greenspace in Houston. When Governor Ann Richards appointed her to the Texas Parks and Wildlife Commission (TPWC), she became the first environmental advocate to serve on that board. Generations of Houstonians know her name from exploring the natural beauty of Terry Hershey Park, established in 1989 along a six-mile stretch of Buffalo Bayou on Houston's west side.

Andrew Sansom, former executive director of TPWC, remembers Hershey as the "first and strongest advocate for state parks on the Texas Parks and Wildlife Commission." Other admirers call Hershey "a force of nature," while she wryly referred to herself as a "philosopher housewife." By any account, she has been one of the most influential environmental activists the city has ever known. Her efforts put a bright spotlight on the need to preserve the area's bayous and united a coalition of activists, resulting in a fundamental shift in the way that bayous are perceived and treated by local, state, and federal entities.

However, events intervened that thwarted full development of the Civic Center. The floods of 1929 were the worst in Houston's history, and inundated the areas along Buffalo Bayou. Shortly thereafter, the Great Depression began, leading to the abandonment of the new City Hall proposal and cessation of further acquisition of property. Nevertheless, some important public institutions were built on the north and south sides of the bayou, such as Jefferson Davis Hospital, the Houston Housing Authority complex, and DePelchin Faith Home.

By the late 1940s, spurred perhaps by the development of the San Antonio River Walk, the public was again calling for improvements to the land on both banks of Buffalo Bayou west of downtown. But by this time, changes had come to the area that made it difficult to beautify. Roads, including Memorial Drive and Buffalo Drive (now Allen Parkway), had eaten into the acreage, as had a massive cloverleaf traffic exchange, more suitable for a freeway than a parkway, that was constructed to connect Waugh Drive, Memorial Drive, and Heights Boulevard.

This drift away from Comey's vision and others meant that by the 1950s, efforts to create a well-planned Civic Center had essentially come to a halt. And Buffalo Bayou itself was losing much of its integrity. Due to flood control measures inspired by a massive flood in 1935, the waterway was rechanneled in several locations and virtually stripped of its vegetation between Shepherd Drive and downtown.

In 1966, even more drastic changes were suggested by the U.S. Army Corps of Engineers, which proposed that Harris County completely straighten the seven-mile stretch between Shepherd Drive and West Belt (currently Beltway 8/West Sam Houston Tollway), line the bayou's banks with concrete, and eliminate the vegetation in a heavily wooded area. The citizen response to this plan has been called the birth of Houston's environmental consciousness.

When Memorial resident Terry Hershey realized that trees were being torn down in her neighborhood without any public notification or input, she helped form Buffalo Bayou Preservation Association (now Bayou Preservation Association, BPA). Hershey was BPA's first president; oilman and developer George Mitchell was its second. Hershey and Mitchell recruited Memorial resident Frank C. Smith Jr., and the three of them collaborated with then-new Congressman George H.W. Bush to stop the redevelopment, leading to Bush inviting Hershey to speak before Congress. Construction

①
Ethel B. Houston transporting passengers along Buffalo Bayou.

②
Elaborately landscaped Sam Houston Park.

③
San Jacinto Street, 1929.

was halted and the U.S. Army Corps of Engineers' proposal was withdrawn. Eventually, the U.S. Army Corps of Engineers changed its policies for approving such projects to allow for greater citizen input.

During the 1960s, development continued along Buffalo Bayou's banks, including the American General office complex, Allen House apartments, a Holiday Inn, and Fonde Recreation Center.

Attention returned to the land along Buffalo Bayou in 1972, when The Wortham Foundation built the first system of hike and bike trails, as well as the Gus S. Wortham Memorial Fountain in 1978.

Also in the 1970s, the late Houston architect Charles Tapley drew plans for the entire Buffalo Bayou Park area, which resemble what Buffalo Bayou Partnership eventually accomplished with the park's recent renovations, completed in 2015.

With Buffalo Bayou Park's redevelopment, Arthur Comey's early-twentieth-century vision for the waterway has now largely been fulfilled, with greenspaces, amenities, and adjacent development.

Buffalo Bayou Park today serves as a monument to the foresight and determination of the many citizens, leaders, and designers who helped keep the vision alive. After more than one hundred years in the making, the completed Buffalo Bayou Park is now an icon and widely renowned landmark that has instantly found a place in the hearts of Houstonians and visitors alike.

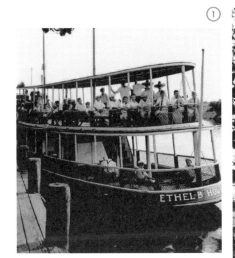

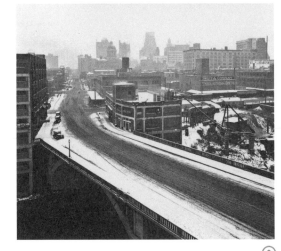

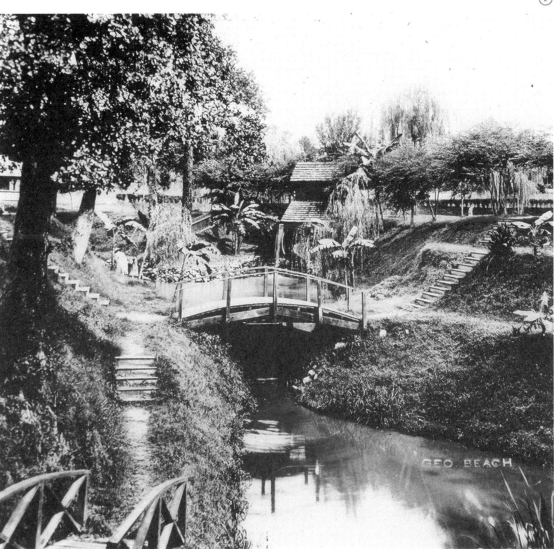

① ② ③

2012
Buffalo Bayou Park
construction begins

2014
Jackson Hill and
Carruth bridges
completed • Sandy
Reed Memorial Trail
(concrete trails) and
Kinder Footpaths
completed • Eleanor
Tinsley Park improve-
ments completed

2015
Johnny Steele Dog
Park completed •
Anthony Thompson
Shumate and John
Runnels public art
works installed •
Visitor centers at
Lost Lake and The
Water Works com-
pleted • Buffalo Bayou
Park Grand Opening
Celebration

2016
Buffalo Bend
Nature Park Phase II
completed • Critical
downtown trail link
completed • Buffalo
Bayou Park Cistern
opened to the public •
Sunset Coffee
Building at Allen's
Landing completed

2017
Buffalo Bayou east
sector master plan
completed

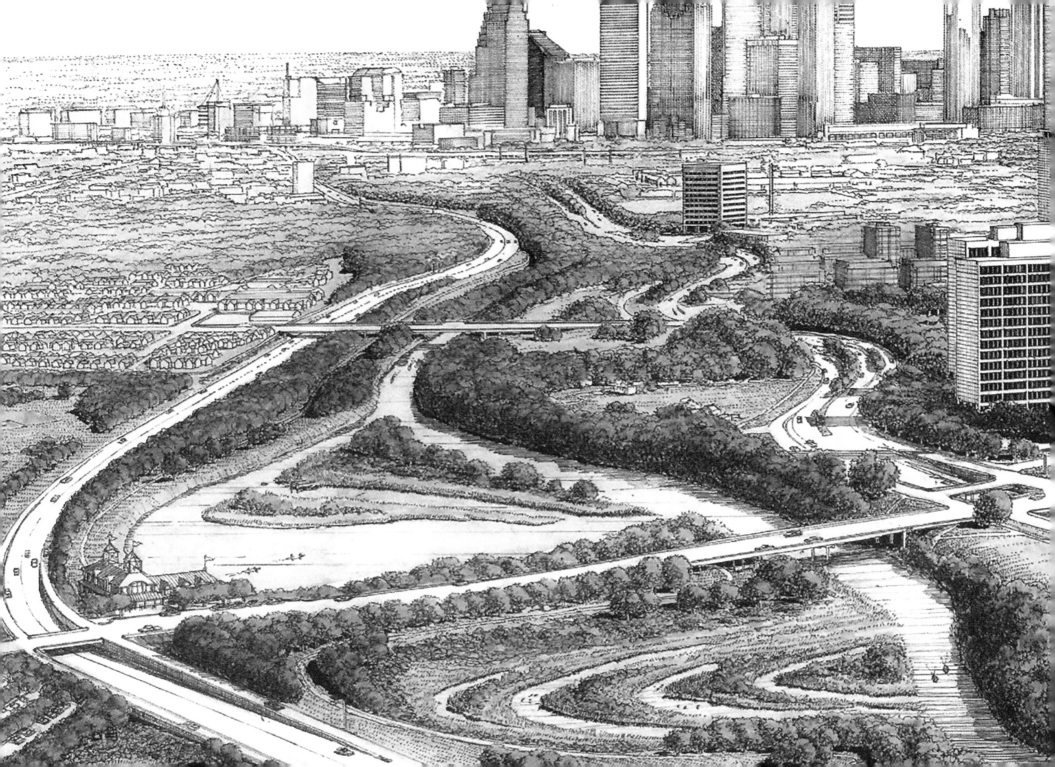

PART 2

BUFFALO BAYOU PARTNERSHIP'S

MISSION, MILESTONES, AND MASTER PLAN

Great cities have been renewing themselves along their waterfronts for decades. Whether New York's Harbor, Chicago's Lakefront, Pittsburgh's Three Rivers, or Chattanooga's Riverfront, cities large and small have found value in developing regional-scale amenities that create a vivid sense of place and offer tangible opportunities for recreation, living, entertainment, and urbanity. Houston's Buffalo Bayou is no exception.

Since its founding in 1986 by Mayor Kathy Whitmire, the non-profit Buffalo Bayou Partnership (BBP) has been steadfastly planning and strategically implementing improvements along Houston's historic waterway. From just west of downtown to ten miles east at the Port of Houston Turning Basin, parks, hike and bike trails, and public art have all played a role in creating an urban greenway that has brought new life and prosperity to America's fourth-largest city.

But before BBP could begin developing parks, the organization had to transform the city's vision of its waterways. Houston had come to prefer its "Space City" moniker and had almost forgotten that it was also the "Bayou City" after the channelization and concrete-lining of most bayous—except of course, Buffalo Bayou. Now BBP was asking Houstonians to think of

Buffalo Bayou "not as its backyard but its front yard," in the words of BBP chair emeritus and Wortham Foundation trustee Brady Carruth. "You can't do anything on Buffalo Bayou," Carruth remembers hearing. He believed that successful capital projects would be key to opening the public's eyes to the possibilities of Buffalo Bayou.

BBP scored its first success with the widely hailed Sesquicentennial Park, a twenty-two-acre greenspace in the heart of downtown's Theater District. Developed over a span of ten years beginning in 1988, the park's design resulted from an international competition and served as an early demonstration of Buffalo Bayou's enormous potential.

Allen's Landing was another park that benefited from BBP's early revitalization work. This historic downtown landmark had been languishing for decades before BBP restored its decaying wharf and made other significant site improvements. Houstonians took real notice when the historic Sunset Coffee Building, built in 1910, was repurposed in 2016. Once home to a coffee roasting business and the psychedelic club Love Street Light Circus Feel Good Machine in the 1960s, the building was reborn to house paddlecraft and bicycle rentals, a café and rooftop terrace, along with BBP's offices.

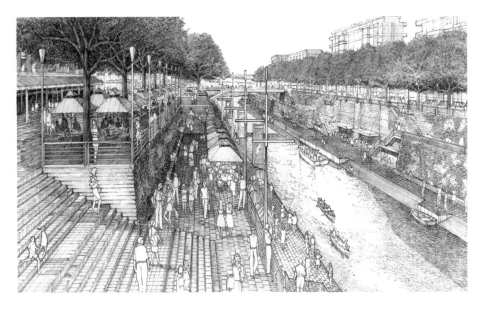

BUFFALO BAYOU AND BEYOND MASTER PLAN

Believing that the Millennium was the opportune time to dream and think big, Buffalo Bayou Partnership, working with the City of Houston and Harris County Flood Control District, embarked on a historic master planning effort in 2000 with a nationally recognized multi-disciplinary consultant team headed by the late Jane Thompson (Thompson Design Group–Boston), a leader in waterfront development throughout the world.

Over eighteen months, hundreds of committed citizens, business leaders, and neighborhood residents participated in workshops, focus groups, and design sessions to share their dreams and to build consensus for Buffalo Bayou's future. The Master Plan, *Buffalo Bayou and Beyond*, is a people's plan, developed by Houstonians with a vision for their historic waterway

and deep concern for the future of their city.

By balancing the themes of conservation and development, the Master Plan invites Houstonians to explore a deeper relationship between nature and the city with new perspective. The plan maintains that nature is not a decorative ornament, but an essential system. It also emphasizes that Buffalo Bayou's restoration builds value into Houston's economy and creates an improved quality of life to sustain and attract residents.

The visionary *Buffalo Bayou and Beyond* Master Plan, with its beautifully rendered images of waterfront neighborhoods and expansive parks, captured the public's imagination when it appeared. Although there was some early skepticism, Houstonians soon realized this was a plan that would not sit on the shelf.

Opening Sabine Promenade in 2006, a twenty-three-acre greenspace just east of Buffalo Bayou Park, put Buffalo Bayou on the map not just locally, but nationally and internationally. Lauded for its unique design under a network of elevated freeways, the park has garnered a multitude of landscape architecture and urban planning awards. The park also served as an impetus and precedent for what was to come six years later—Buffalo Bayou Park.

While BBP has been busy transforming downtown's waterfront and Buffalo Bayou Park, the organization also has been working along the bayou's east sector (U.S. 59 to the Port of Houston Turning Basin), where it is building hike and bike trails and strategically purchasing abandoned industrial properties. With a nature park located near the Port of Houston Turning Basin, a site that serves as the home base for Rice University's Crew Team and the Texas Dragon Boat Association, and industrial artifacts that are treasured and creatively used by local artists, Buffalo Bayou's east sector is now coming into its own.

Houstonians can explore the long-lived relationship between the city and its historic waterway by taking part in BBP-sponsored boating and walking tours; the annual Buffalo Bayou Partnership Regatta, Texas' largest canoe and kayak race; and a variety of cultural events sponsored in cooperation with the city's leading arts organizations.

By getting their hands dirty planting trees, removing invasive plants and vines, and picking up trash, more than two thousand volunteers each year connect with Buffalo Bayou and become valuable stewards.

BBP also protects the bayou's unique ecology through Clean & Green, an innovative program sponsored by Harris County Flood Control District, the Port of Houston Authority, and Shell Oil. Using specially designed boats, a field crew and community service workers rid the bayou of more than 3,000 cubic yards of trash and debris each year.

Buffalo Bayou Partnership has developed a new vision of the bayou and therefore of Houston itself. Today, Buffalo Bayou is truly "Houston's most significant natural resource," as BBP's mission states. Think about that for a moment: Buffalo Bayou is the city's most precious natural resource—not oil.

ANNE OLSON

BUFFALO BAYOU PARTNERSHIP PRESIDENT

"My appreciation for greenspace and nature stems from my growing up in a very beautiful part of the country—upstate New York's Finger Lakes region," says Anne Olson. "I also lived across the street from a five-acre city park until I moved away for college, and my parents lived there all of their married lives. We were so lucky to have this park and all that it offered so close."

In Houston, Olson first became interested in Buffalo Bayou in the early 1990s when she was the executive director of the Greater East End Chamber of Commerce. The bayou snakes through Houston's East End en route to the Port of Houston and is central to the neighborhood's identity, but its importance and potential were not recognized by the city as a whole. "Buffalo Bayou, and especially the east sector, had little visibility," she says now. "It was difficult for Houstonians to see the vision."

She joined the Buffalo Bayou Partnership board and in 1995, when BBP decided to hire a full-time staff rather than rely on volunteers, Olson became the organization's first president. She has since guided BBP through its remarkable growth and accomplishments, establishing a record of vision and tenacity in the process.

A senior fellow of Houston's American Leadership Forum, Olson has received the Houston Park People Leadership Award and the Alchemy Catalyst Award for "transforming the ordinary into the exemplary through excellent design."

Today Olson is focused on her old East End stomping ground as BBP turns its attention to implementing the development promised by the 2002 Master Plan to that often-neglected area of the city. New trails and parks will extend all the way to the Port of Houston Turning Basin, tangibly linking the city's west and east sides, and creating its center in the process.

WE'VE MADE BUFFALO BAYOU PART OF HOUSTON AGAIN.

ANNE OLSON

THERE IS A SENSE IN ALL CORNERS OF HOUSTON THAT THERE IS SUCH A THING AS URBAN MORTALITY: A CITY WILL START, GROW, THEN PEAK OR PLATEAU OR PLUNGE, AND THERE ARE MOMENTS OF DECISION THAT DETERMINE IF THE FUTURE POINTS UP OR DOWN. HOUSTONIANS SEEM TO BE SENSING THAT FATE AND THE FUTURE IS NOW IN THEIR HANDS, THAT TRUE QUALITY OF LIFE IS WITHIN REACH IF DECISIONS ARE BOLD AND FAR-SEEING, RESPONSIVE TO PUBLIC NEEDS AND HUMAN DESIRES IN A PEOPLE-CENTERED ENVIRONMENT. IT IS TRULY NOW OR NEVER.

JANE THOMPSON, Thompson Design Group, speaking at presentation of *Buffalo Bayou and Beyond* Master Plan, August 2002

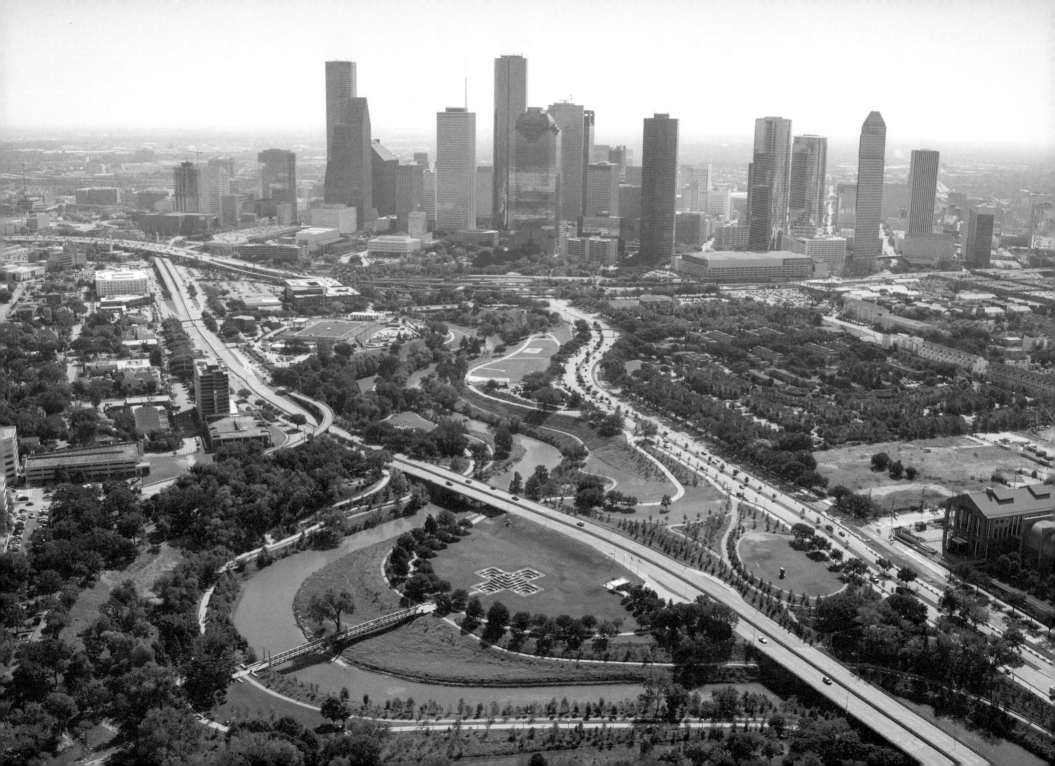

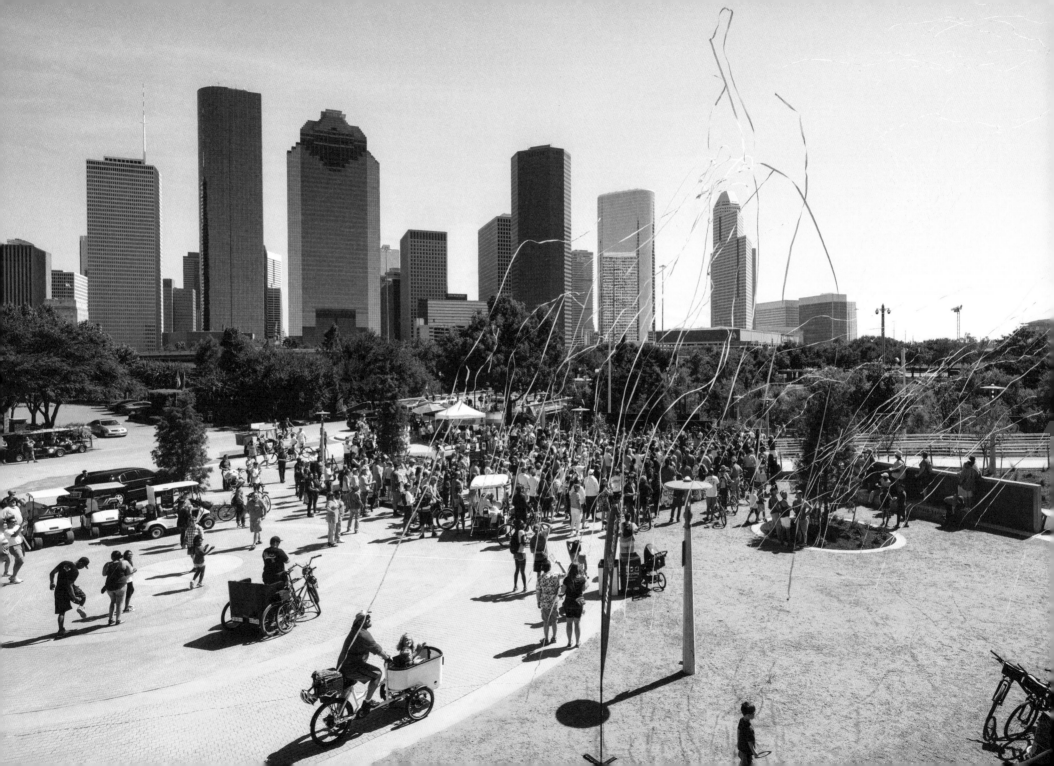

PART 3

CATALYST FUNDING AND COMMUNITY PARTNERS

With the *Buffalo Bayou and Beyond* Master Plan and projects such as Sabine Promenade and Sesquicentennial Park completed, the promise of additional funds for the next phase of Buffalo Bayou's redevelopment came in 2010 when Houston philanthropists Rich and Nancy Kinder expressed interest in working with Buffalo Bayou Partnership. Looking for ways to provide the city with transformational gifts, the Kinders believed they could make an impactful difference by contributing to education, quality of life, and park projects, all so essential to a twenty-first century city when highly skilled workers can choose where they want to live and work.

One such project was Discovery Green, a vibrant twelve-acre park developed from a downtown parking lot, made possible with a $10 million grant from the Kinder Foundation and other major gifts from Houston's leading foundations. According to Nancy Kinder, Discovery Green Conservancy's founding chair, the park's "phenomenal success," measured in the number of people who use it and the amount of real estate development it generated, inspired the couple to look for more greenspace to enhance. Because of Buffalo Bayou Partnership's past successes, the Kinders were confident that the organization could deliver on a big project. In fact, when discussions first started, the couple encouraged BBP to "think bigger," recalls Rich Kinder.

BBP began working on its plan to create the $58 million Buffalo Bayou Park we know today, and the Kinders generously committed a catalyst $30 million donation, one of the largest private gifts in the history of Houston's park system. Believing that projects achieve lasting impact through commitments from the public sector, the Kinders stipulated that their gift was contingent on the City of Houston agreeing to provide long-term funding for the park's maintenance and operations.

As a long-time supporter of Buffalo Bayou, former Mayor Annise Parker was one hundred percent committed to the project from day one. "Whenever I'm asked what is my favorite place in Houston, I always say Buffalo Bayou," she points out. "It was easy for me to jump on board."

Mayor Parker recalls her first meeting with Nancy Kinder. "She was not only passionate about the project but she was definitely a tough negotiator."

Talks between the City and the Kinder Foundation came to a successful end when the Downtown Tax Increment Reinvestment Zone (TIRZ) #3, a special district created by the City that directs increased tax revenue in an area to fund strategic public improvements in the same area, committed maintenance and operations funding until the year 2043 when the district ceases to exist. The City itself committed to continuing the same level of funding during two renewal terms lasting until the year 2096.

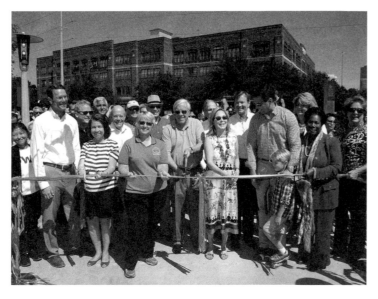

"This was a new process," says Andy Icken, the City's chief development officer. "The City had never gone through an assurance of maintenance like this. But we took it to City Council and received a unanimous vote of approval. We feel great about every aspect of the project."

The Downtown TIRZ was not the only public sector partner involved in Buffalo Bayou Park's revitalization. After hearing about the project and learning of its potential flood management benefits, Mike Talbott, former executive director of the Harris County Flood Control District (HCFCD), committed $5 million of the agency's funds to the effort.

"We were very excited to be able to work in such an environmentally sensitive area, to support the vision of having a world-class park," says Talbott. HCFCD's efforts were put to an immediate test in the spring of 2015 with heavy Memorial Day weekend rains. "There would have been more flooding and damage to the park if this project hadn't been in place," Talbott points out.

Other community partners collaborated in more discreet ways. Katy Prairie Conservancy worked with BBP to create 17 acres of "pocket prairies" throughout the park. Jaime Gonzalez, Katy Prairie Conservancy conservation education director, says, "The prairie is Houston's heartland—it's who we are and what we value. Putting a prairie in a public park helps Houstonians connect with their native landscape." Houston Arts Alliance was still another project partner assisting BBP in overseeing Buffalo Bayou Park's public art installations.

Additional enhancements such as the Rosemont Bridge, Jaume Plensa's *Tolerance* sculptures, realignment of the Sandy Reed Memorial Trail, and renovation of the Cistern, which were funded by other partners, broadened the $58 million park improvement project resulting in a combined $70 million investment for upgrades and improvements within Buffalo Bayou Park.

Joe Turner, director of Houston Parks and Recreation Department, explains that through this process, the City has discovered just how important parks are to the citizens of Houston. "What we have learned from the collaboration and development of this park, aside from the partnership aspect, and the nuts and bolts of creating the agreement, is that Houstonians love their parks—and if you build them they will come. And they have come. The park is filled with activity every day. Whether it is for a morning run or bike ride, a trip to the dog park, or a meal at The Dunlavy—the park is alive with people. I'd like to think that if the City's first park designer, architect Arthur Coleman Comey, were to see Buffalo Bayou Park today he would be pleased with its development, and he would say his goals for the park have been achieved."

Buffalo Bayou Park is a testament to Houston's unparalleled philanthropy, strong public-private partnerships, and civic collaboration. This cooperation between so many entities has caused some to reconsider Houston's reputation as an unplanned city, notes Pratap Talwar, 2002 Master Plan consultant. "Planning and implementing at this level is not common. There are few initiatives of this scale anywhere."

RICH AND NANCY KINDER

PHILANTHROPISTS

THINK BIGGER.

RICH KINDER

When Houston philanthropists Rich and Nancy Kinder signed the Giving Pledge in 2011, committing to give away ninety-five percent of their total wealth during their lifetime, they were already providing Houston with transformational gifts. They were also interested in giving to causes that contributed to the city's quality of life. "We thought we could really make a difference," Nancy Kinder says.

They began in 2004 by fostering the development of Discovery Green. Encouraged by the success of that downtown park, they were eager to help develop more greenspace. They already took walks in Buffalo Bayou Park and saw room for vast improvements in its design and facilities. They offered to help fund improvements and encouraged BBP to think beyond jogging trails and bike paths, saying, "You're not thinking big enough."

When presented with plans for the park, the Kinders contributed $30 million of the expected $58 million total—with the firm stipulation that the City agree to maintain the park well into the future. Because a city council cannot commit to spending beyond its term, this requirement proved challenging to implement, but the Kinders persevered until the deal could be worked out, and now Buffalo Bayou Park has a secure future.

The Kinders have moved on to help fund other parks, including the historic Emancipation Park in the city's Third Ward and the Bayou Greenways 2020 plan, which links the area's 150 miles of bayou greenspace into a network, indeed transforming the city.

ORIGINS
Seeking to balance
conservation and
development,
the redesign and
revitalization of
Buffalo Bayou Park
has dramatically im-
proved quality of life
for area residents
and significantly
enhanced Houston's
image. Discover
details of the design
strategy and nu-
ances of the unique
elements of the park
in Part 4.

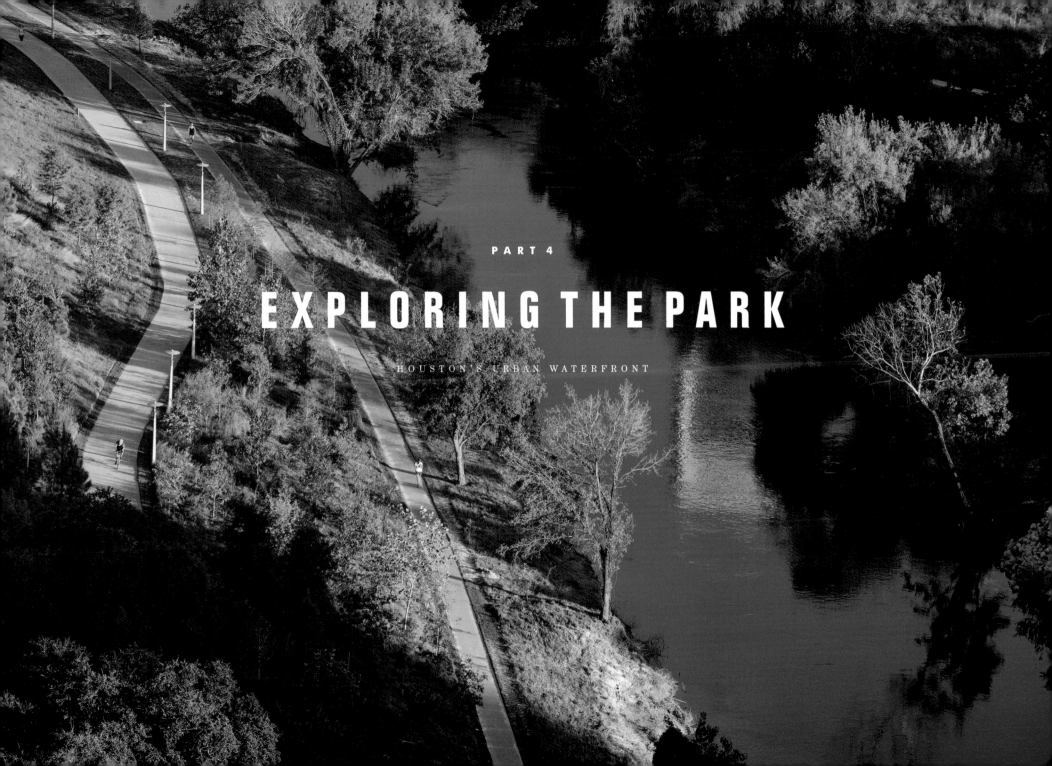

EXPLORING THE PARK

HOUSTON'S URBAN WATERFRONT

WITH ITS 160 ACRES REVAMPED AND REPLENISHED WITH NATIVE PLANTINGS, THOUGHTFULLY DESIGNED TRAILS, AND EYE-CATCHING FACILITIES, BUFFALO BAYOU PARK EXEMPLIFIES HOW TO CREATE A THRIVING GREENWAY WITHIN A WELL-ESTABLISHED URBAN ENVIRONMENT.

By embracing the waterway's natural beauty and enticing the public to experience that beauty, Buffalo Bayou Park offers a lively setting for Houstonians, visitors, gleeful canines, and a wondrous array of wildlife.

Guy Hagstette, who served as project manager for the park improvements and is currently director of parks and civic projects for the Kinder Foundation, hopes Buffalo Bayou Park will inspire other city planners and park designers. "The most interesting parks are rooted in a particular ecosystem that has been imprinted with a dynamic urban form," says Hagstette. "At its heart, Buffalo Bayou Park is about this bayou and the city that has grown along its banks."

Preserving and reinforcing the plant species that naturally thrive in that ecosystem amidst modern-day Houston's dynamic cityscape has created an unmistakable sense of place, both for visitors to Buffalo Bayou Park and for those who live and work in the adjacent neighborhoods. The park has blossomed into Houston's signature landmark, simultaneously symbolic of the city's heritage and enduring spirit.

Varied landscape zones provide a rich experience for people and wildlife. All trees and plants were selected for their hardiness and role in the park's ecosystem.

LANDSCAPE ZONES

 PERENNIAL GARDENS

● RIPARIAN EDGES

 BRIDGES

● RAMBLES

● WOODLANDS

 DESTINATIONS

● LAWNS & GROVES

 PUBLIC ART

● MEADOWS & PRAIRIES

"Our goal was to reinforce the park's historic landscape on a couple of different levels: to be resilient during major storms and flooding and to utilize native vegetation to enhance the space we were creating for the park," says Kevin Shanley, lead designer with SWA Group, the park's planning and landscape architecture consultant firm.

Taking advantage of the site's topography, shaded woodland areas open up to outdoor rooms, creating a pleasing rhythm of shade and light, cool and warm, quiet and active spaces. Starting with the formal rooms such as Eleanor Tinsley Park, The Water Works, and the Police Officers' Memorial, the park then moves into less defined, more natural open spaces westward toward Shepherd Drive.

According to Scott McCready, landscape architect and SWA Group principal, when you look at a cross-section of the bayou corridor as in nature, you see that different plants grow in the upper and lower levels. Hardwoods tend to grow in upland areas, such as the live oaks that are so typical of Houston. Being an urban site, the soil tends to compact from heavy foot traffic, creating limitations on plant varieties that will thrive in those areas. Moving down the slope, there is mid-story and then the lower level, which features a riparian composition. Here the soils are more fertile and loose, which encourages trees such as red oak, pecan, cottonwood, sycamore, and magnolia.

SWA assessed the subtle landscape zones and amplified them to help the public recognize these different elements. The design team also worked to enhance the sense of seasonality experienced by park visitors. Cypress trees offer wonderful fall color. During springtime, the proliferation of wildflowers and the vibrant emergence of redbud, Mexican plum, fringe trees, and sweetbay magnolia provide reliable and prolific displays. These seasonal sightings serve as landscape events to be anticipated year after year.

OUR GOAL WAS TO REINFORCE THE PARK'S HISTORIC LANDSCAPE ON A COUPLE OF DIFFERENT LEVELS: TO BE RESILIENT DURING MAJOR STORMS AND FLOODING AND TO UTILIZE NATIVE VEGETATION TO ENHANCE THE SPACE.

SCOTT McCREADY, SWA Group

LANDSCAPE ZONES

Distinct zones within the park called for their own
special mix of vegetation. The park's planting
plan strategically addresses the various types of
terrain and their natural appearance and purposes.

RIPARIAN EDGES

RAMBLES

WOODLANDS

LAWNS AND GROVES

MEADOWS AND PRAIRIES

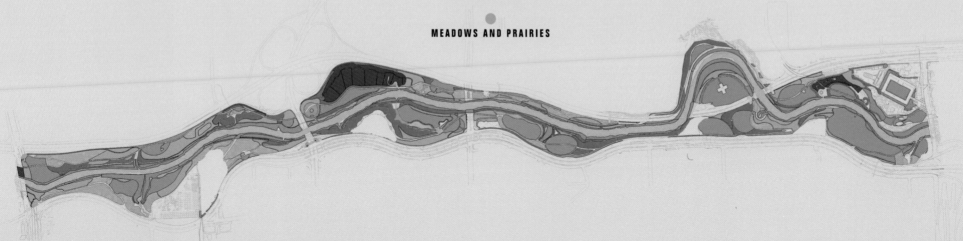

→

Native cypress trees, in particular, were used due to the nature of their aggressive root systems and resilience to siltation.

 # RIPARIAN EDGES

Due to the bayou's fluctuating water levels and turbidity, the riparian zone is one of the most challenging aspects of Buffalo Bayou Park's landscape. Other than trees, it is very difficult to establish vegetation within the bayou's low-bank areas and along its tributaries and outfall edges, particularly due to unnatural extended high flows from two large upstream dams. SWA worked with Harris County Flood Control District (HCFCD) to establish a strategy for planting native riparian trees to help stabilize the lower banks. These trees also serve a critical function of providing improved habitats along the bayou corridor.

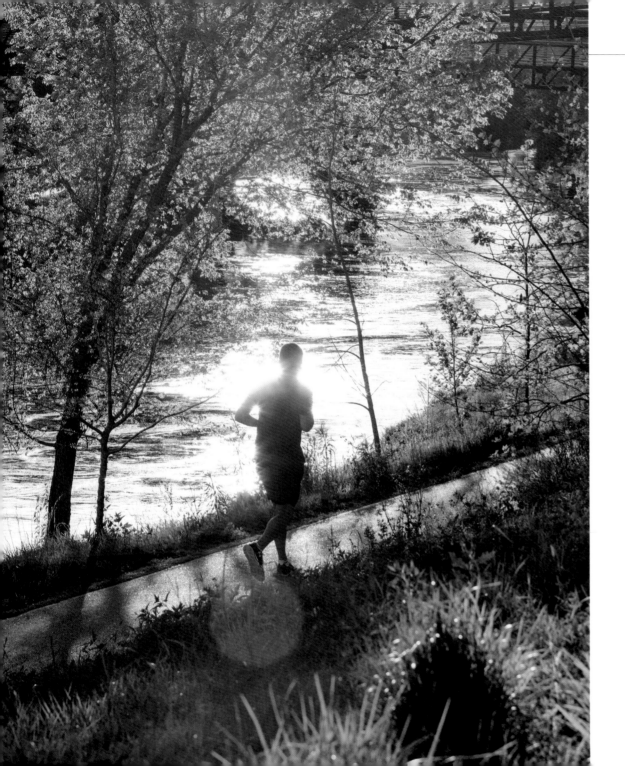

ᴏᴏ

FLOOD MANAGEMENT

Using natural channel design techniques, Harris County Flood Control District (HCFCD) reshaped Buffalo Bayou, attempting to both reflect the natural evolution of the waterway and create a shape that makes it more stable as Buffalo Bayou responds to its ever-changing environment. From Shepherd Drive to Sabine Street, the HCFCD team undertook a two-year channel conveyance project, which involved removing sediment, restoring and reshaping the bayou's banks, removing invasive plant species, and installing bank stabilization material such as vegetated walls and bankfull benches to catch and deposit silt coming from the west.

While under construction and since the official opening, the park has been tested when major floods, some the largest in Houston's history, inundated the landscape. In all cases, the park responded as it was designed to, with the native landscape bouncing back quickly and the flood benches capturing and depositing silt.

FLOOD STATISTICS

Measurements taken at Buffalo Bayou at Shepherd Drive (flood stage is 28 feet):

2015 MEMORIAL DAY
Crest: 33.73 feet

2008 HURRICANE IKE
Crest: 32.42 feet

2001 HURRICANE ALLISON
Crest: 40.2 feet

DEC. 9, 1935 RECORD CREST (PICTURED):
49 feet

* Source: Harris County Flood Control District

→
GREEN TREE NATURE AREA

● RAMBLES

Thoroughly natural sites, such as Green Tree Nature Area, located east of Waugh Drive, resemble the original landscape of the park. Here SWA preserved the many older, existing trees, and opted to do very little trail work, only adding a bit of mulch to define the path. "We didn't want to intervene too much because we wanted this to be a portion of the park that is as close to wild as possible," says Scott McCready. Working with an environmental oversight committee, the SWA team discovered that even though vines might be choking trees, they also provide valuable habitats for various species of birds. "We learned to take a holistic perspective and not just look at it from a human perspective," adds McCready.

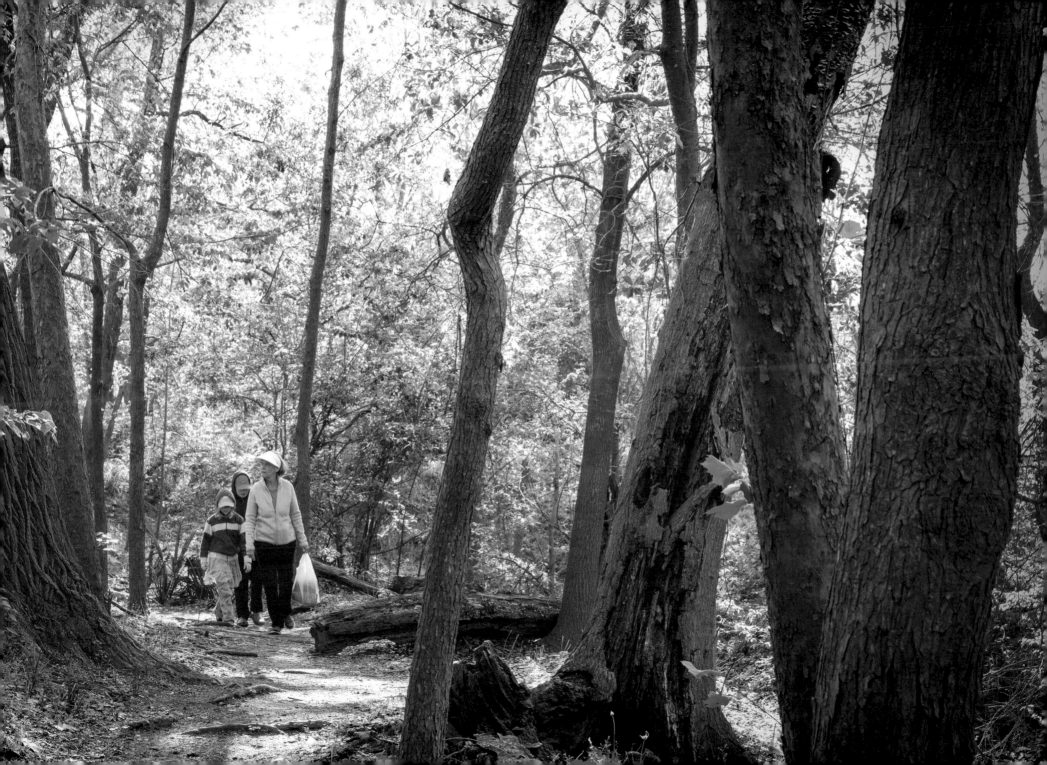

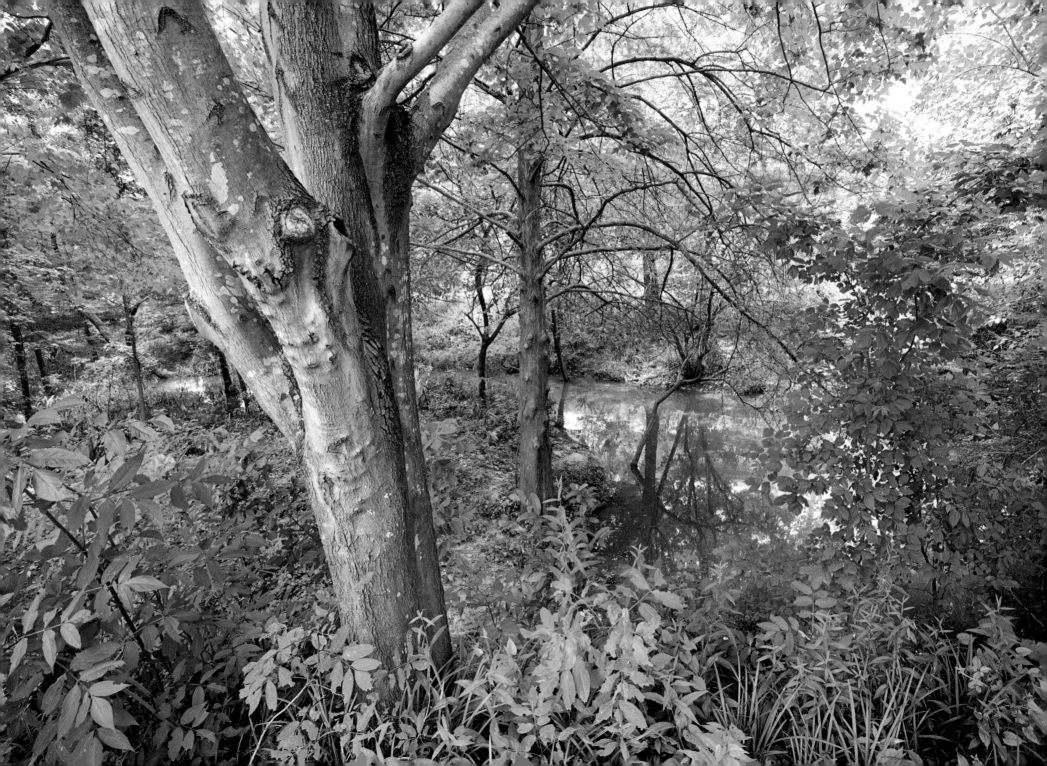

More than 14,000
new native trees
were planted
throughout the park.

WOODLANDS

Woodland areas were significantly increased throughout Buffalo Bayou Park. Native woodlands, located away from recreational activity, contain a full mix of understory plants. Cultured woodlands, located along trails and near lawns, were planted so they can be maintained to prevent undergrowth from obscuring sightlines for park users.

PARKS ARE NOT LIKE STATIC BUILDINGS BUT ARE INSTEAD LIKE LIVING CREATURES.

KEVIN SHANLEY

KEVIN SHANLEY

LANDSCAPE ARCHITECT

By studying how Buffalo Bayou naturally shaped the landscape, Kevin Shanley developed the overall landscape design and philosophy for the park project. He envisioned and translated his ideas into the design plan after extensive first-hand exploration of the park's terrain.

Now semi-retired, Kevin Shanley worked as a principal for SWA for over 30 years and was lead designer for Buffalo Bayou Park. Shanley grew up on the West Coast, where he acquired many of the typical misunderstandings that outsiders have about Houston. In an essay published in 2000, Shanley wrote, "My first experience of Houston was a descent through the clouds from 30,000 feet. With expectations of seeing a dry western landscape, I was surprised and delighted by the carpet of treetops—a marvelous sea of green."

After realizing the great need to prioritize and improve parks across the city, Shanley developed his vision of dedicating land along the bayous and streams in the area to allow them room to function as natural rivers, while providing open space for tree-shaded trails and wildlife habitat throughout the city.

Shanley began to imagine what Buffalo Bayou Park could mean to the city. He recalls, "One weekend, I drew a plan by hand that included (various) ideas from others for improving the park. You could put it on the wall and talk about what could be there." This drawing was copied and passed around; former Mayor Bill White hung a version on his wall.

SWA's Scott McCready worked closely with Shanley after formal park design began. He says, "Kevin's hand-drawn master plan is very close to what was built. He knew the area extremely well; he spent countless hours there on foot. When he laid his big ideas on the page, they were predicated on a thorough understanding of the land." (Charles Tapley's vision remains in the park to this day as well.)

"In the end, my greatest satisfaction comes from watching the thousands of Houstonians and visitors from around the world find their own special way to experience the bayou and to form important memories of the park, and take those home with them."

Looking forward, he went on to say, "Parks are not like static buildings but are instead like living creatures. In the creation of a park there are scope decisions, design and construction deadlines and budgets to be met. We are really just creating a framework for a small but important piece of the much larger landscape of the bayou's watershed. The park will grow and evolve over time as the vegetation matures and as the community discovers more ways to experience and enjoy the bayou and its green corridor."

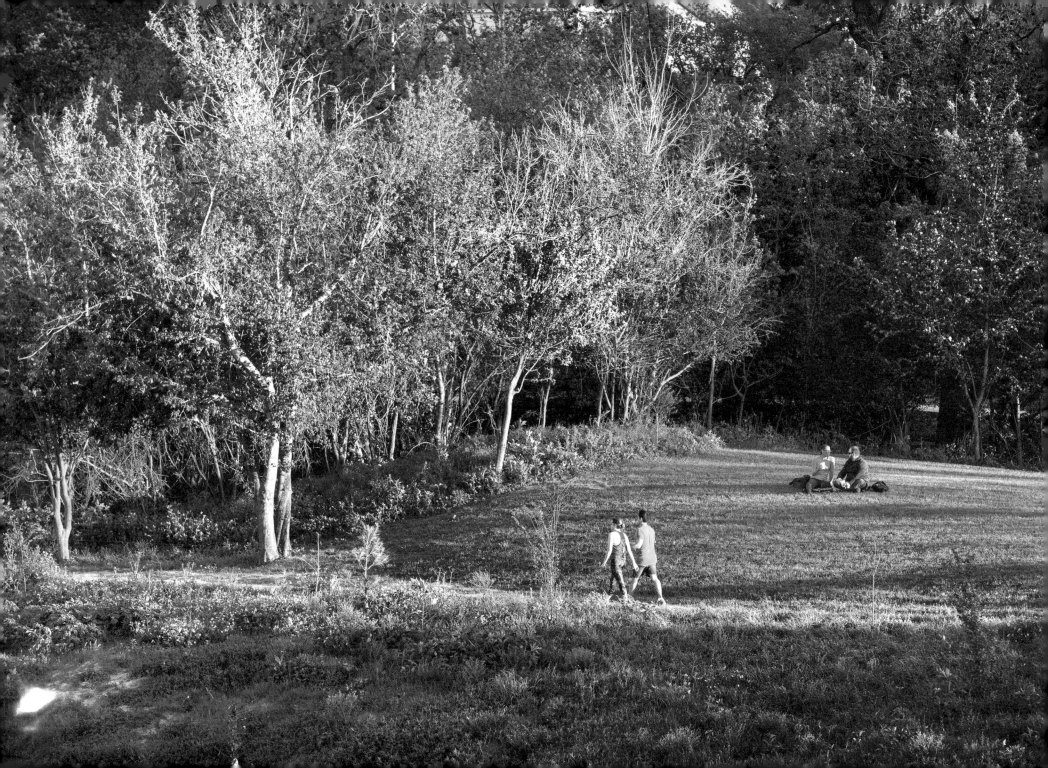

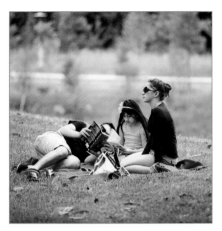

Lawns within the park offer inviting spaces for families and friends to gather and savor nature's beauty, as well as make lasting memories.

LAWNS AND GROVES

Buffalo Bayou Park's existing vast expanses of rough mown grass were reduced to the relatively flat areas most used by the public and transformed into beautiful lawns. It is very apparent that the lawns at Eleanor Tinsley Park and the Police Officers' Memorial are now benefiting from intensive horticultural care. Lawns are strategically located to accommodate various forms of recreation, including some slopes that are used for cross-country training in otherwise flat Houston.

PLAINS COREOPSIS IN BLOOM

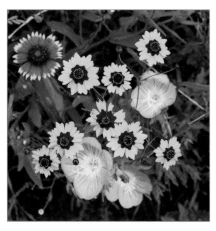

Native wildflowers, such as Indian blanket, plains coreopsis, and evening primrose put on a colorful display throughout spring and summer.

MEADOWS AND PRAIRIES

Beyond the rambles and groves, prairies and meadows are another way that park planners looked back to the city's past in designing for the future. Jaime Gonzalez, conservation education director of Katy Prairie Conservancy, describes the countryside before the city was built: "Most of Houston was prairie. It would have been forest, but fires, buffalo, and droughts wiped out most of the trees and produced grasslands." Buffalo Bayou Park is now home to 17 acres of both prairies and meadows. "We restored plants that were along Buffalo Bayou previously," Gonzalez says. "The native milkweeds, wildflowers, and grasses provide structure and color texture."

With the addition of these plants that draw high-impact pollinators, along with other plantings, the park attracts more wildlife than in years past. The grasslands provide seeds for migratory birds, along with cover and nectar for birds, caterpillars, and other insects. Most importantly, Gonzalez says, the park is designed to create a series of "ecotones" or areas where two or more habitats come together. Owls can perch in trees, but hunt in grasslands. The park features three different adjoined habitats—riparian forest, grassland, and the bayou itself—giving it very high biodiversity.

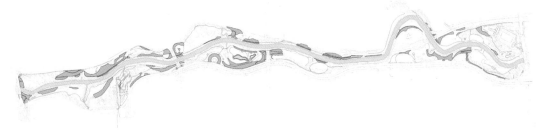

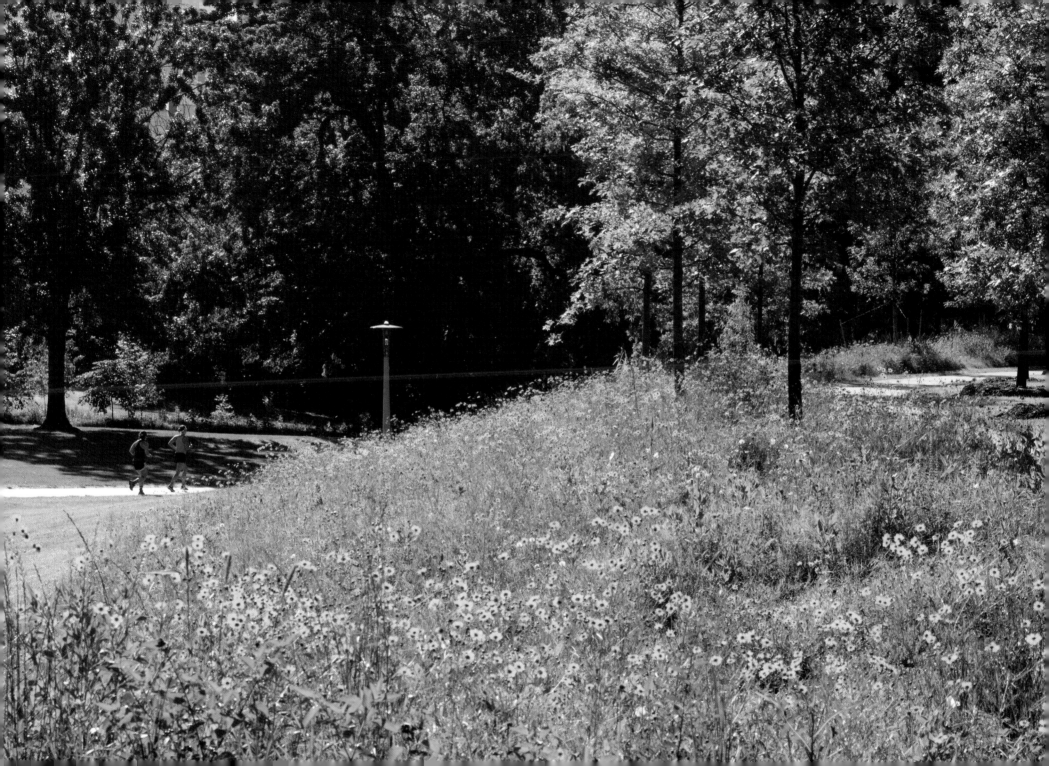

THREE FORMAL PERENNIAL GARDEN AREAS ALONG THE SOUTH BANK PROVIDE GATEWAY MOMENTS AND STRONG SEASONAL COLOR.

SCOTT McCREADY, SWA Group

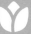

PERENNIAL GARDENS

While the majority of Buffalo Bayou Park's plant life is native, there are strategically located pockets of perennial gardens that have a more cultivated feeling and are designed to showcase the bountiful seasonal colors available to Houston area gardeners.

1

ELEANOR TINSLEY AND JANE GREGORY GARDENS

2

LOST LAKE GARDENS

3

GUS S. WORTHAM MEMORIAL FOUNTAIN GARDENS

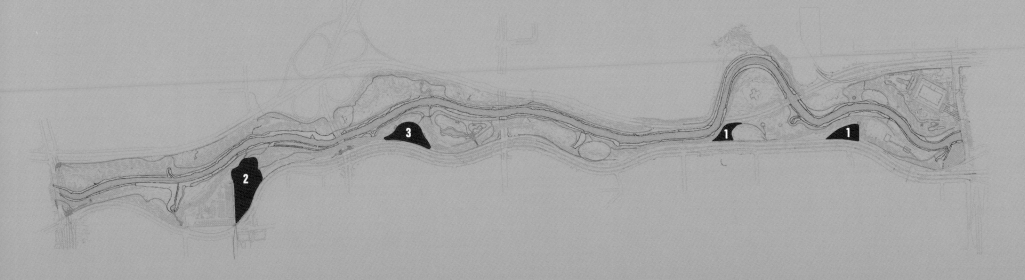

JANE GREGORY GARDEN

Plantings in the Jane Gregory Garden provide an elegant showcase encircling Henry Moore's *Large Spindle Piece*, giving the sculpture a grand presentation. Here, native and Piedmont azaleas offer a pale pink flourish during early spring.

These areas feature plants closely associated with Houston residential landscapes —dwarf Walter's viburnum and dwarf Barbados cherry shrubs along with redbud and southern magnolia trees.

 ①

ELEANOR TINSLEY AND JANE GREGORY GARDENS

Eleanor Tinsley Park showcases one of the most visible perennial gardens. For the Boston-based Reed Hilderbrand landscape team, the garden presented challenges and its own distinct character. The designers had to work around a parking area, which they put to their advantage by blending it with a wide walking path that leads to smaller paths, connecting to the garden.

Just west of Eleanor Tinsley Park, the charming Jane Gregory Garden is an intimate strolling space initially created in 2002 to honor a local master gardener. Reed Hilderbrand expanded this site by embellishing the plant palette, adding loblolly pines, redbuds, and silverbell trees, along with American beautyberry, camellia, and purple anise. Indigo, Turk's cap, and Katie Ruellia provide an expanse of groundcover. The garden's benches make a lovely spot for contemplating Henry Moore's *Large Spindle Piece*.

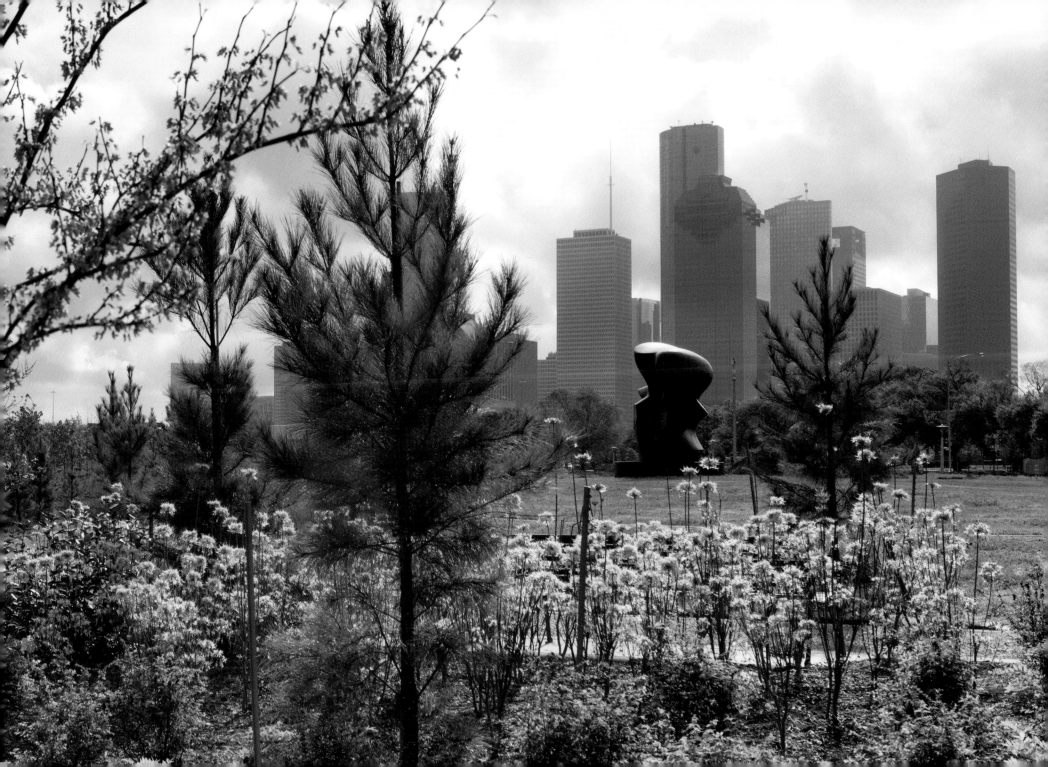

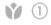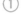

Jane Gregory Garden and Eleanor Tinsley Garden, designed by Reed Hilderbrand of Boston, offer a mix of shade trees, seasonal color, and a variety of plant textures. These perennial gardens make delightful spots to visit year round. Walking paths and benches invite park users to stroll or sit a spell to appreciate the scenery at hand.

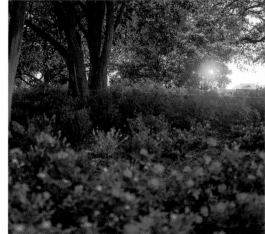

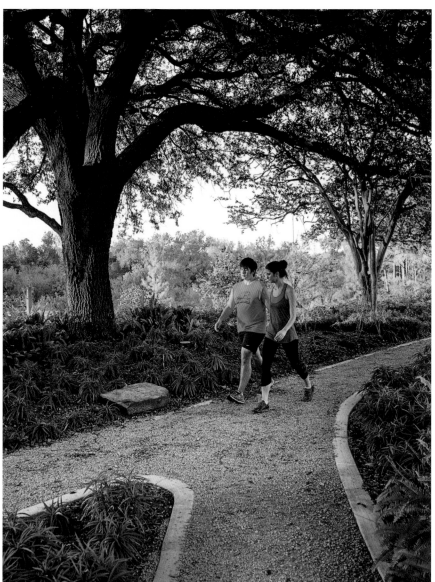

GUY HAGSTETTE

BUFFALO BAYOU PARK PROJECT MANAGER

PEOPLE LOOK TO HOUSTON AS A GREAT MECCA FOR GREENSPACE ... GUY HAS HELPED [ACCOMPLISH THIS].

MINNETTE BOESEL, former Mayor Annise Parker's assistant for cultural affairs

"Buffalo Bayou has always been a part of my life," says Buffalo Bayou Park project manager Guy Hagstette. He grew up near the waterway and remembers playing "where the streets went down to the water." For a high school project, he filmed himself on a canoe trip down the bayou.

After graduate school in the mid-1980s, Hagstette tried to make his way in the architecture world during the oil bust. He and some friends won the international competition to design Sesquicentennial Park on Buffalo Bayou, but creating the park in the middle of the economic downturn was difficult. "Other guys [partners] moved on when there wasn't any money," Hagstette recalls. "It made no financial sense for me to stay, but I believed in the potential of Buffalo Bayou through the grim times." It took fourteen years to complete both phases of the park. Hagstette also worked for Central Houston, Inc., the Downtown District, and in the Mayor's office, where Bill White tapped him to lead Discovery Green through its birth and opening years.

More a creator than a manager, Hagstette next went to Buffalo Bayou Park, where he worked behind the scenes, dealing more with the inner workings of the city than working at the designer's table. He was also one of the park's faces when presenting the plans to the public. "I can't tell you how many times I had to answer the question, 'Why can't we have our own [San Antonio-style] River Walk?'" Very patiently, Hagstette reminded people that Buffalo Bayou Park lies in a floodplain, so a river walk would be inadvisable.

As an extension of his work on Buffalo Bayou Park, Hagstette is now working as an advisor on Bayou Greenways 2020 as director of parks and civic projects with the Kinder Foundation. Bayou Greenways 2020 is a transformative project that envisions a continuous park system along Houston's major waterways within the city limits, with plans to transform more than 3,000 acres along Houston's bayous into publicly accessible greenspace and connect 150 miles of hike and bike trails. When the project is complete, six out of ten Houstonians will live within 1.5 miles of a Bayou Greenway.

Speaking about the influence Hagstette has had on Houston, former Mayor Annise Parker's assistant for cultural affairs Minnette Boesel said, "I think Houston is different because of Guy."

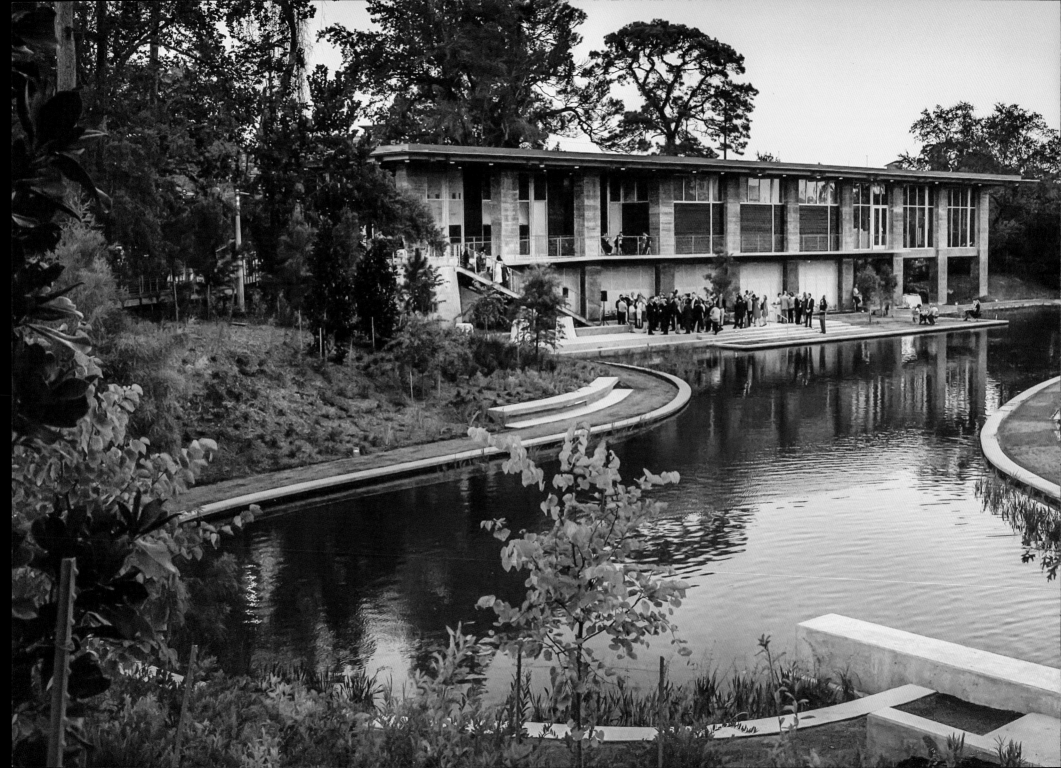

LOST LAKE VISITOR CENTER AND THE DUNLAVY

LOST LAKE GARDENS

The landscape team also created a uniquely formal wetland garden in the Lost Lake area. Reed Hilderbrand's Doug Reed says that the Lost Lake Gardens presented the firm with an opportunity to achieve a dramatic effect, given it was carved out of a ravine. Reed organized the garden around a man-made, circulating stream that flows down a series of steps. Then the water travels through a pattern of circular pools that overflow into the ravine valley with its spillway appearing to float in the middle of the pond.

The plantings at Lost Lake Gardens are water loving and include sweet-bay magnolia, bald cypress, and redbud trees, purple anise and dwarf palmetto shrubs, and inland sea oats. Scott McCready notes that Lost Lake is an extreme topological site, which represents some of the steepest slopes in the park, some having as much as 20 to 30 feet of grade change from the water surface elevation to the bordering street.

TRAILS

Since the 1970s, the trails along the bayou's banks have drawn joggers, walkers, and cyclists to Buffalo Bayou Park's undulating terrain. Before their renovation, the aging trails were one of the few significant park features, but they left much to be desired.

Today, the 10-foot-wide concrete jogging and bicycling trails, officially named the Sandy Reed Memorial Trail, provide a much smoother, safer surface for park users and offer a 4.6-mile loop within the park, thanks to funding and implementation by Texas Department of Transportation and the City of Houston.

Anticipating a significant increase in traffic along this multi-use trail, park planners designed the five-foot-wide asphalt Kinder Footpath solely for pedestrians. These trails are located lower on the banks and closer to the water's edge and at many points wind through beautiful woodlands, providing a quieter and more reflective experience of the bayou corridor. "Personally, I am drawn to the park's rich variety of environments – quiet and active, prospects and valleys, urban and wild," says project manager Guy Hagstette, reflecting on the overall experience of the completed park.

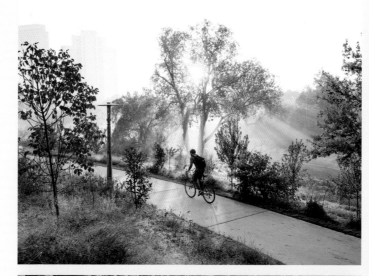

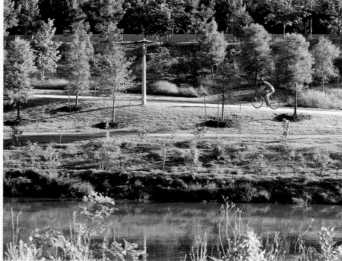

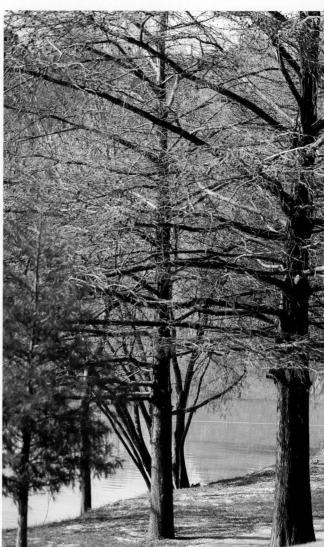

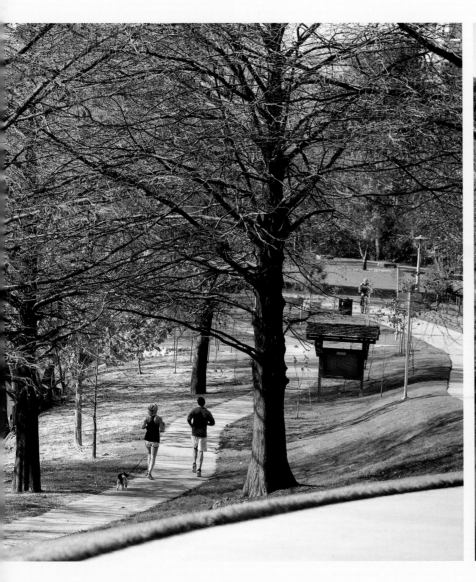

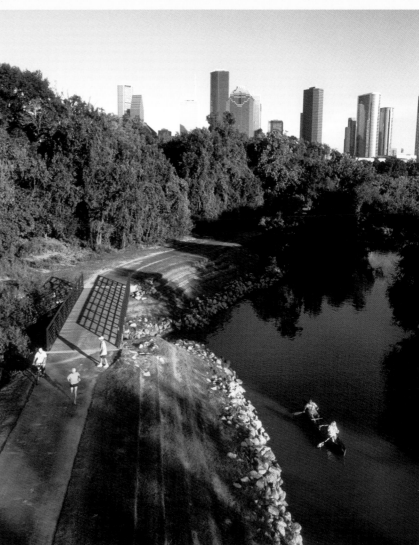

The trail system within the renovated park offers pedestrians and cyclists a series of vistas. Portions of the trail feature long, gently curving views, while other sections twist and turn so these views are framed and contained by trees, plants, and grassy slopes. These alternating vistas yield an outdoor experience like no other in the city.

Day lilies, Turk's cap, and scarlet sage further enhance the site with color.

③ GUS S. WORTHAM MEMORIAL FOUNTAIN GARDENS

Another formal garden embraces what is perhaps the most noticeable and best-known landmark along Allen Parkway, the Gus S. Wortham Memorial Fountain. Centered along The Wortham Foundation Grove, the fountain is known as the "Dandelion Fountain" for the way water mists out of its copper tubes in all directions, creating a delicate spray that looks like it could be scattered by a breath, like seeds. SWA and Reed Hilderbrand framed the area with a collection of native trees including Mexican sycamore and Monterrey oak and further enhanced the area with yaupon holly and shrubs such as coralberry and American beautyberry. This tasteful space is dotted with shaded benches, site lighting, and small open-air pavilions.

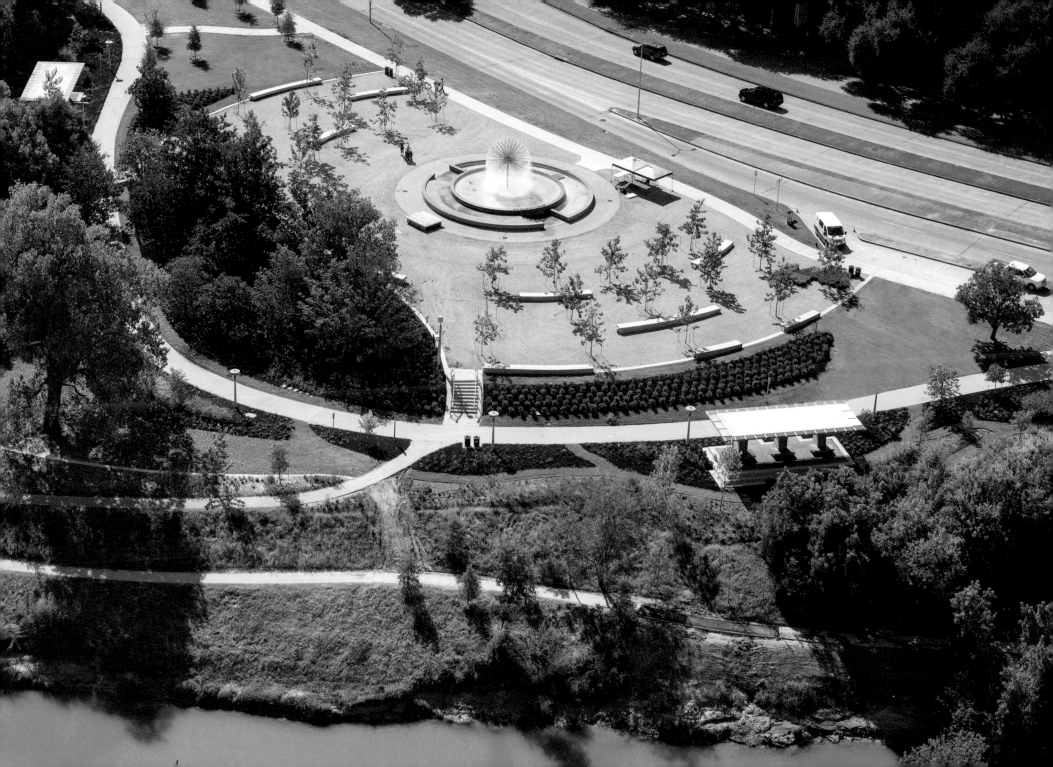

BRIDGES INSTALLED WITHIN BUFFALO BAYOU PARK SERVE AS STUNNING ATTRACTIONS THAT QUITE LITERALLY CONNECT PEOPLE TO THE GREENSPACE. THEIR SCULPTURAL STYLE AND DURABLE STEEL CONSTRUCTION PROVIDE ACCESS TO VARIOUS DESTINATIONS AND REVEAL SCENIC VISTAS.

BRIDGES

When Buffalo Bayou Partnership issued its 2002 Master Plan,
increasing access to the bayou and making navigation easier were
prime objectives. At that point in time, the 2.3-mile stretch of
Buffalo Bayou Park had very few crossing points, which bicyclists,
runners, and walkers had to share with heavy car traffic. Since
then, four bridges have been built for foot and bike traffic.

1

ROSEMONT

2

CARRUTH

3

JACKSON HILL

4

SHEPHERD DRIVE

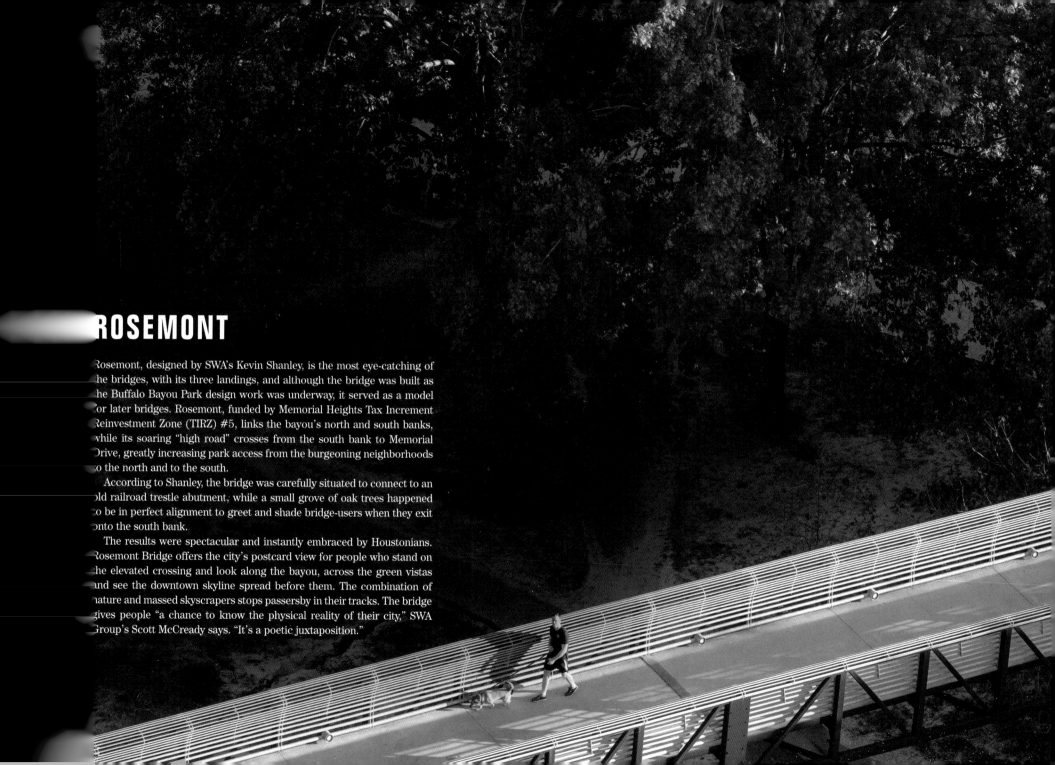

ROSEMONT

Rosemont, designed by SWA's Kevin Shanley, is the most eye-catching of the bridges, with its three landings, and although the bridge was built as the Buffalo Bayou Park design work was underway, it served as a model for later bridges. Rosemont, funded by Memorial Heights Tax Increment Reinvestment Zone (TIRZ) #5, links the bayou's north and south banks, while its soaring "high road" crosses from the south bank to Memorial Drive, greatly increasing park access from the burgeoning neighborhoods to the north and to the south.

According to Shanley, the bridge was carefully situated to connect to an old railroad trestle abutment, while a small grove of oak trees happened to be in perfect alignment to greet and shade bridge-users when they exit onto the south bank.

The results were spectacular and instantly embraced by Houstonians. Rosemont Bridge offers the city's postcard view for people who stand on the elevated crossing and look along the bayou, across the green vistas and see the downtown skyline spread before them. The combination of nature and massed skyscrapers stops passersby in their tracks. The bridge gives people "a chance to know the physical reality of their city," SWA Group's Scott McCready says. "It's a poetic juxtaposition."

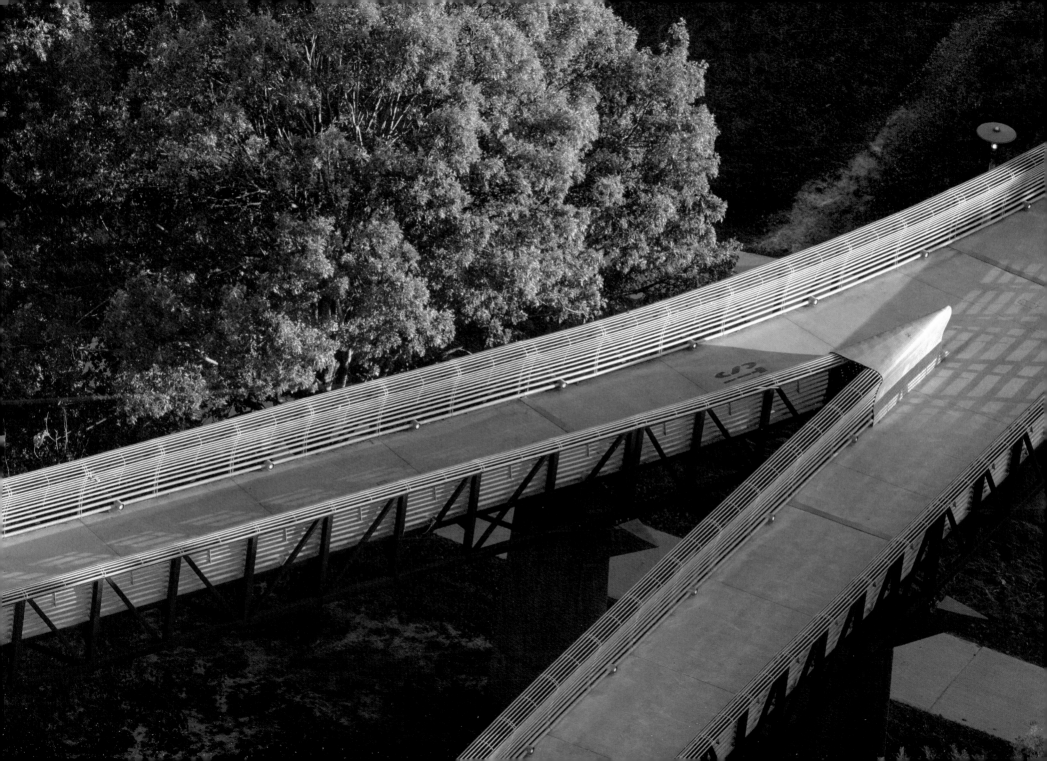

② CARRUTH
③ JACKSON HILL
④ SHEPHERD DRIVE

On axis with the Police Officers' Memorial, Carruth Bridge connects the north bank trail to the areas surrounding the memorial, encouraging visitors to interact with the sculpture as the late artist Jesús Bautista Moroles intended. The bridge also allows park users to savor this relatively quiet section of the park, which lies adjacent to historic Glenwood Cemetery.

Like Rosemont Bridge, the Jackson Hill Bridge connects the north side of Memorial Drive to Buffalo Bayou Park, near the Lost Lake area. And via an existing pedestrian bridge at Jackson Hill Street, area residents living just north of Buffalo Bayou now have easy access to the park's entire trail system.

Another crucial bridge was installed alongside Shepherd Drive, creating a dramatically safer passage for pedestrians and cyclists than the previous option of a narrow sidewalk on Shepherd that offered no buffer from heavy vehicular traffic. This bridge was federally funded through Texas Department of Transportation, and it connects the north and south banks of the bayou at the western edge of the park.

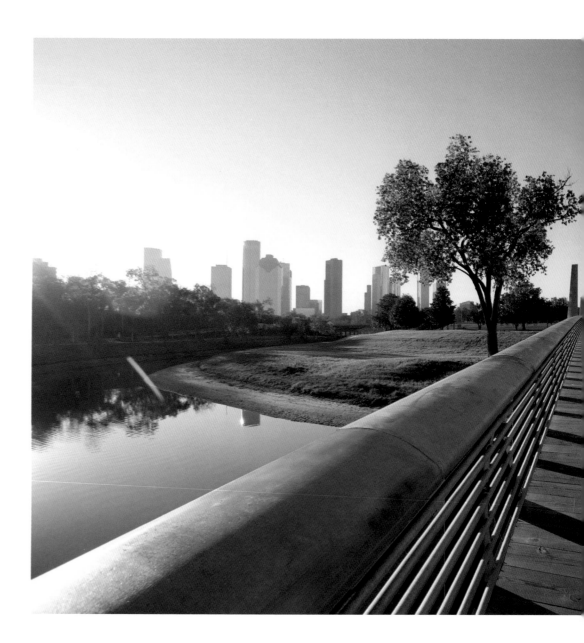

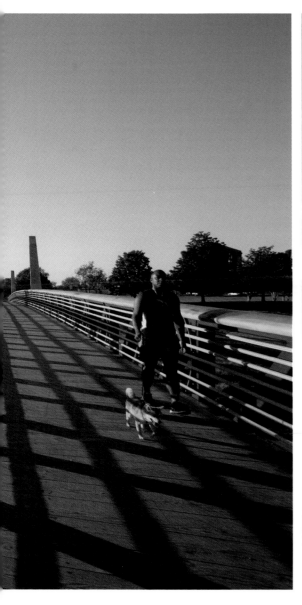

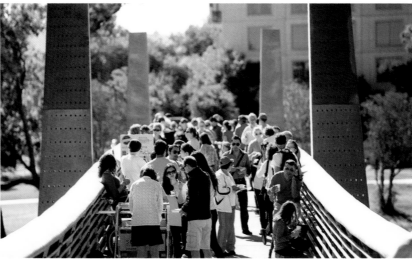

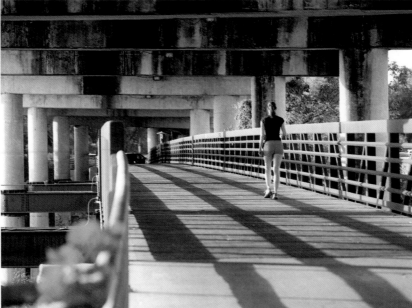

Carruth Bridge captures the eye, beckoning park visitors to explore the Police Officers' Memorial and its surrounding lawn. Just east of Lost Lake, Jackson Hill Bridge spans the bayou and links to another bridge over Memorial Drive, providing safe passage to the park from the north side of the thoroughfare. Shepherd Drive Bridge is an essential crossing, tucked under the street's overpass and alongside ground-level Shepherd. "The bridges are critical, because they allow us to stand over the water and watch it move. They allow us to get in touch with natural elements that shape Houston," says Scott McCready, principal, SWA Group.

LUNAR CYCLE
LIGHTING

Lighting provides an elegant complement to Buffalo Bayou Park's trail system and serves as an advertisement and invitation to enjoy the park.

Created by New York artist Stephen Korns and Hervé Descottes of the international firm L'Observatoire, lighting plays a key role in opening up the park to the public in three significant ways. On the first, most basic level, the lights allow motorists and passersby to see that the park and bayou are actually there. A second function of the lighting system is to provide continuous beads of illumination, clearly showing people where to find the bayou trails. The third benefit of park-wide lighting is the illumination of dark corners such as under bridge abutments, providing an important level of security without necessitating lighting the whole park landscape. Before Korns and Descottes created their artistic design, motorists crossing Buffalo Bayou at night had little idea they were driving over a waterway. And those who wanted to access the bayou were often intimidated by the thought of descending from street level into the unlit depths of its floodplain. Or worse, navigating its dark trails.

This layered effect is one of Buffalo Bayou Park's greatest achievements. The lighting system offers aesthetic, wayfinding, and safety aspects; adding drama to the strategic design and natural curves of the landscape; illuminating trails and helping park users observe well-lit focal points—such as water features, sculptures, and bridges—as landmarks to find their way; and on a larger scale it illuminates Houstonians' often neglected relationship with nature.

Houston has been a city unusually alienated from its own surroundings. There are no mountains or ocean, and the city's most prominent feature—its bayous—have been forgotten and abused over the years. In many parts of the city, the concrete-lined waterways do not look natural at all.

A transcendent element of the lighting plan provides a subtle yet powerful reminder that the city is irrevocably intertwined with nature. The basic lampposts have LED bulbs for white lighting, with a color-changing LED "orb" on top. Starting from Houston's birthplace at Allen's Landing, then along Sabine Promenade to Shepherd Drive, the top bulbs gradually change colors, from white to blue and back again to white, in accordance with the lunar cycle. During a new moon, all the lights turn blue. Korns refers to this lighting scheme as "Houston's moon clock." The distinctive blue lighting calls attention to itself, and by extension, to Buffalo Bayou. The continually changing lighting scheme reminds visitors of the perpetual, yet gradual changes inherent in nature. Explaining the concept, Korns quotes a Japanese saying: "To love nature, catch it as it changes."

The lunar connection goes beyond the aesthetic and natural. "Internationally," Korns points out, "people associate the moon landing with Houston." The blue lighting along Buffalo Bayou helps remind visitors that Houston really is both the Bayou City and the Space City.

FORM & FUNCTION Stephen Korns and Hervé Descottes' ethereal lighting design for the park emits undeniable beauty while it also aids nighttime navigation by lighting the way, showcasing landmarks, and enhancing safety for park users.

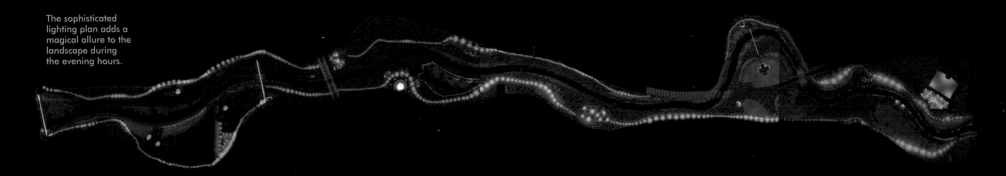

The sophisticated lighting plan adds a magical allure to the landscape during the evening hours.

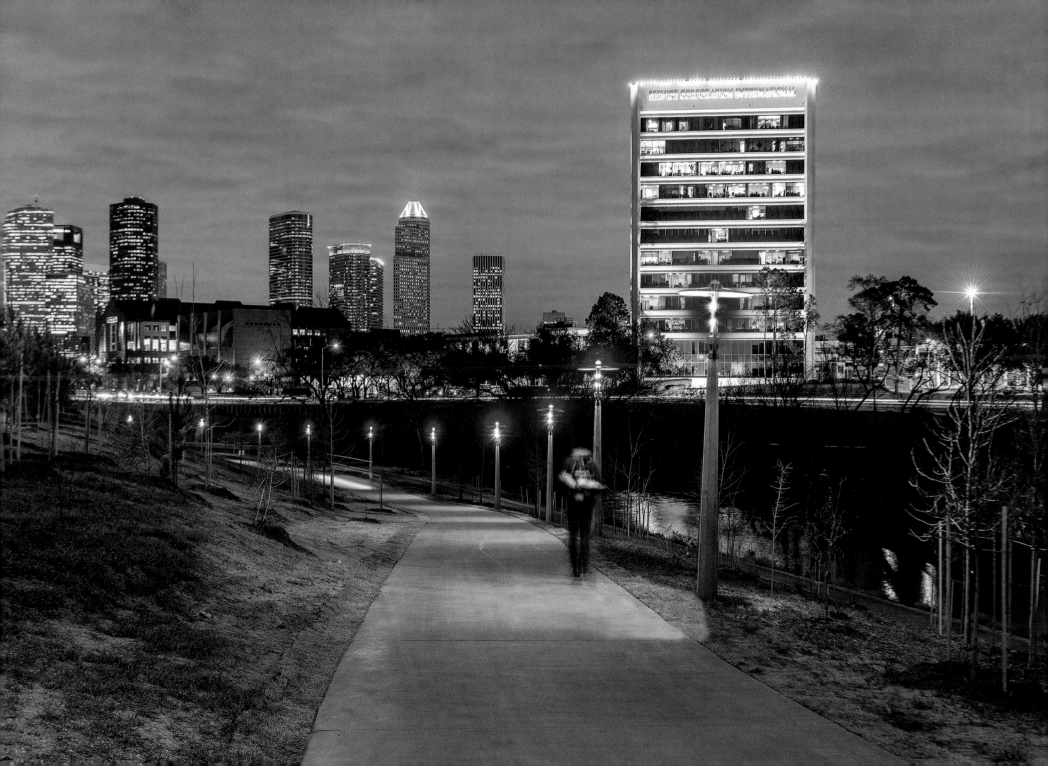

THE OVERWHELMING RESPONSE HAS BEEN THAT PEOPLE OF HOUSTON TRULY LOVE THEIR BAYOU AND ENJOY SEEING OTHER PEOPLE THERE. IT HAS BECOME A SEE-AND-BE-SEEN LOCATION—THEY FEEL THEY ARE PART OF A COMMUNITY, PART OF A SHARED EXPERIENCE.

SCOTT McCREADY, SWA Group

DESTINATIONS

1
THE WATER WORKS

2
CISTERN

3
TAPLEY TRIBUTARY

4
LOST LAKE

5
BARBARA FISH DANIEL NATURE PLAY AREA

6
ELEANOR TINSLEY PARK

7
JOHNNY STEELE DOG PARK

8
WAUGH DRIVE BRIDGE BAT COLONY

→
WORTHAM INSURANCE VISITOR CENTER AND TERRACE

Anchored by the Wortham
Insurance Visitor Center and
Terrace (opposite), the stately
Water Works area welcomes
park visitors with a multitude
of features. While the main
level of the visitor center
provides information and ser-
vices, its upper level inspires a
pause to take in the scenery.
Up on The Brown Foundation
Lawn, the Hobby Family Pavil-
ion serves as a performance
and event space.

THE WATER WORKS

Buffalo Bayou Park's grand gateway is The Water Works
near Sabine Street at the eastern edge of the park. It is
home to a number of the park's most notable features,
including the bi-level Wortham Insurance Visitor Center
and Terrace, offering close-up and wide-angled views
of the downtown skyline, in addition to bike rentals, re-
strooms, refreshments, and a place where visitors can
pick up a park map and have questions answered. The
Brown Foundation Lawn, an elevated expanse, runs to
the west of the visitor center. On the lawn's north edge
stands the open-air Hobby Family Pavilion, providing a
stage for performances and events.

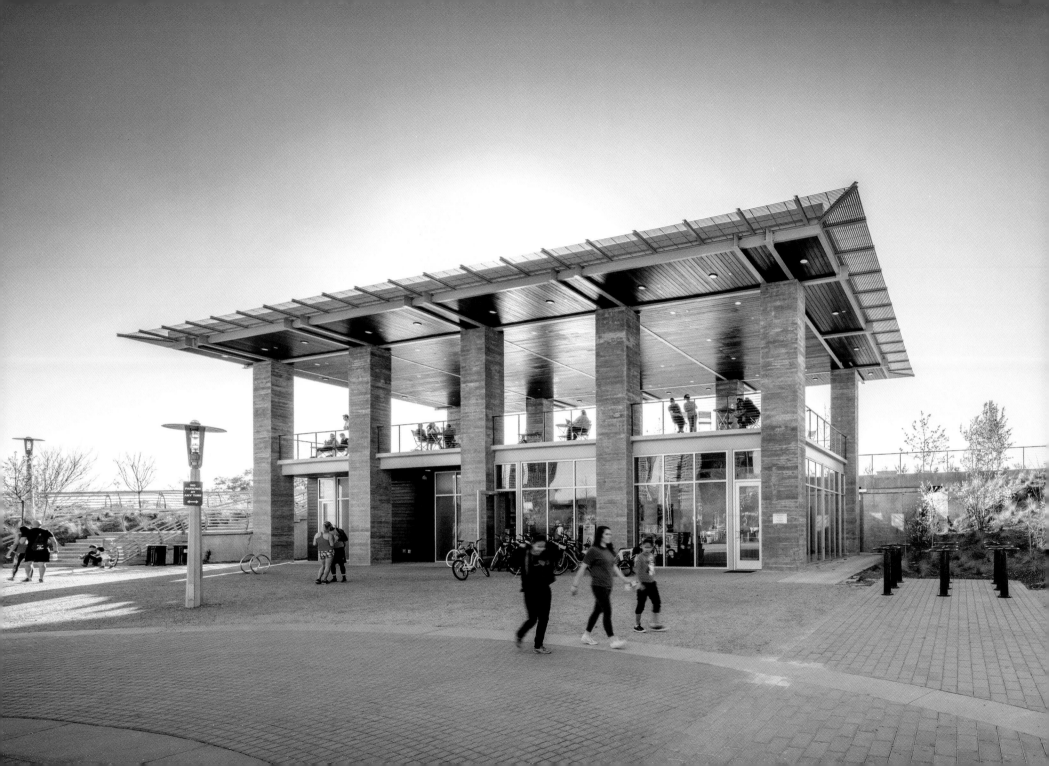

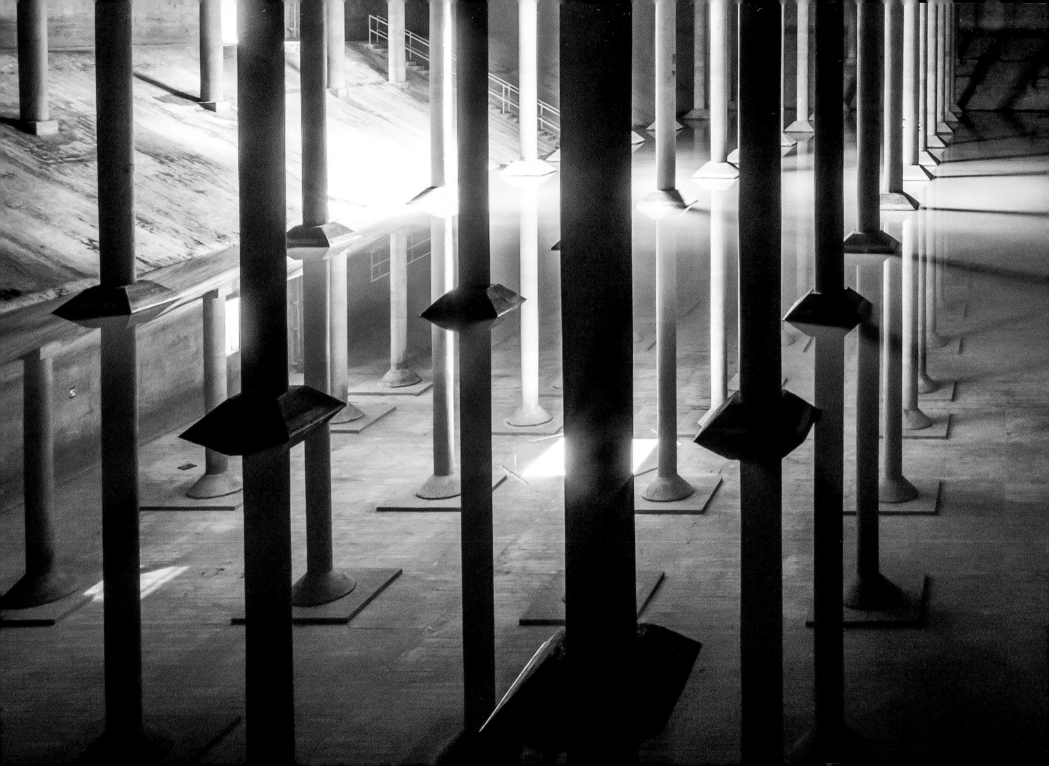

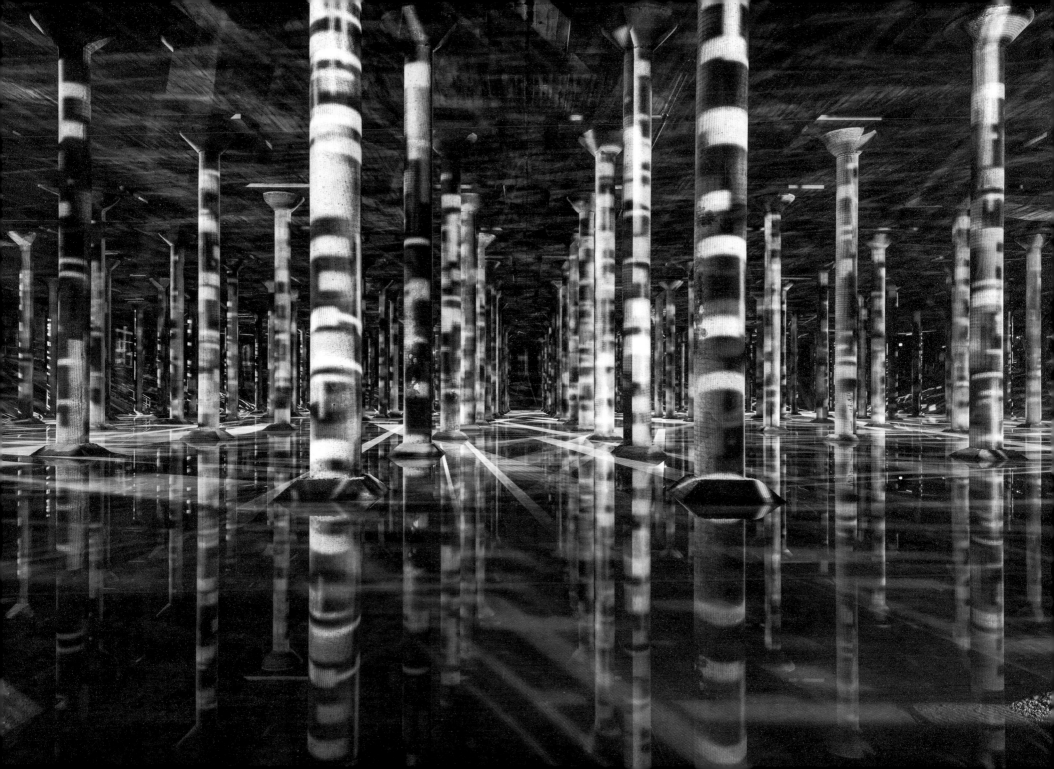

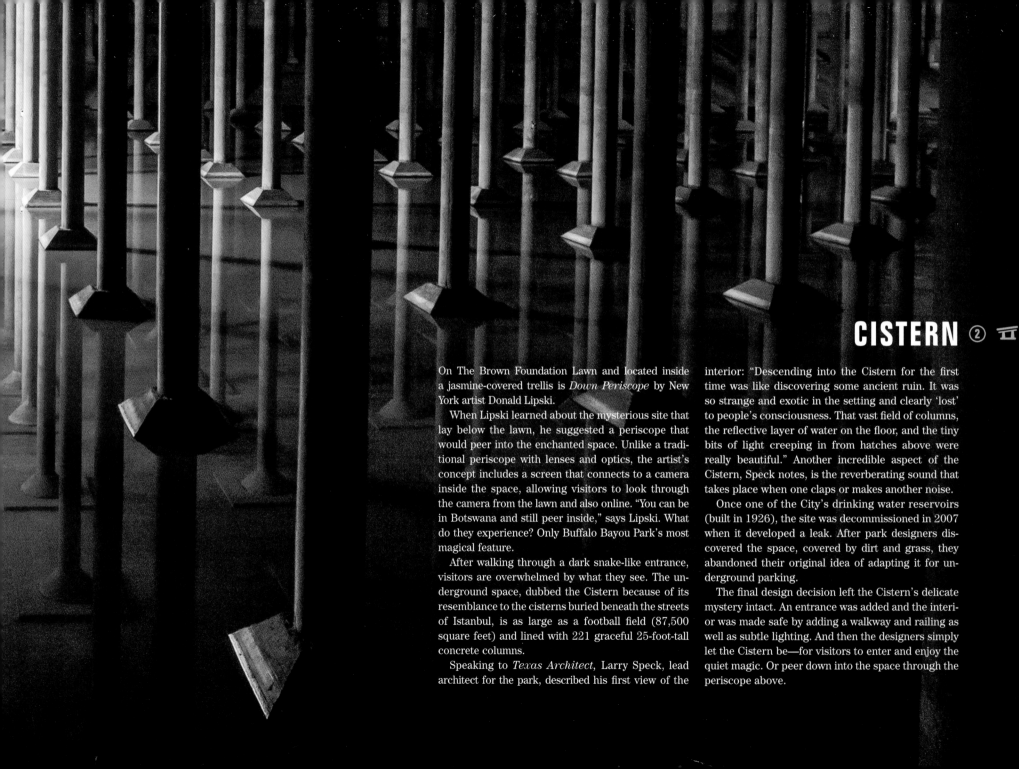

CISTERN ② ⊓

On The Brown Foundation Lawn and located inside a jasmine-covered trellis is *Down Periscope* by New York artist Donald Lipski.

When Lipski learned about the mysterious site that lay below the lawn, he suggested a periscope that would peer into the enchanted space. Unlike a traditional periscope with lenses and optics, the artist's concept includes a screen that connects to a camera inside the space, allowing visitors to look through the camera from the lawn and also online. "You can be in Botswana and still peer inside," says Lipski. What do they experience? Only Buffalo Bayou Park's most magical feature.

After walking through a dark snake-like entrance, visitors are overwhelmed by what they see. The underground space, dubbed the Cistern because of its resemblance to the cisterns buried beneath the streets of Istanbul, is as large as a football field (87,500 square feet) and lined with 221 graceful 25-foot-tall concrete columns.

Speaking to *Texas Architect*, Larry Speck, lead architect for the park, described his first view of the interior: "Descending into the Cistern for the first time was like discovering some ancient ruin. It was so strange and exotic in the setting and clearly 'lost' to people's consciousness. That vast field of columns, the reflective layer of water on the floor, and the tiny bits of light creeping in from hatches above were really beautiful." Another incredible aspect of the Cistern, Speck notes, is the reverberating sound that takes place when one claps or makes another noise.

Once one of the City's drinking water reservoirs (built in 1926), the site was decommissioned in 2007 when it developed a leak. After park designers discovered the space, covered by dirt and grass, they abandoned their original idea of adapting it for underground parking.

The final design decision left the Cistern's delicate mystery intact. An entrance was added and the interior was made safe by adding a walkway and railing as well as subtle lighting. And then the designers simply let the Cistern be—for visitors to enter and enjoy the quiet magic. Or peer down into the space through the periscope above.

In addition to docent-led tours highlighting the history and architecture of this unique industrial site, the Buffalo Bayou Park Cistern is a magnificent public space that houses an ambitious program of changing art installations.

The inaugural art installation in the Buffalo Bayou Park Cistern took place December 10, 2016 to June 4, 2017. *Rain: Magdalena Fernández at the Houston Cistern* featured *2iPM009*, an abstract video piece created by Venezuelan artist Magdalena Fernández that evokes a rain-soaked night. This exhibition was organized by the Museum of Fine Arts, Houston and co-presented by Buffalo Bayou Partnership.

On the southern edge of The Brown Foundation Lawn is the Lee & Joe Jamail Skatepark, a 30,000-square-foot, all-concrete site that put Houston on the skateboarding map. Completed in 2008 by the Houston Parks Board and City of Houston, it boasts two cradles (a skateboarding term for a hemispherical bowl, turned on its side, that allows skaters to invert), including one that may be the biggest in the United States, and also a kidney shaped bowl that is over twelve feet deep at one end. Thanks to the challenges built into the design by Grindline, a premier designer of skateparks, and to the advanced abilities of area skateboarders, the action here is exciting to follow, especially from the safety of the lawn above.

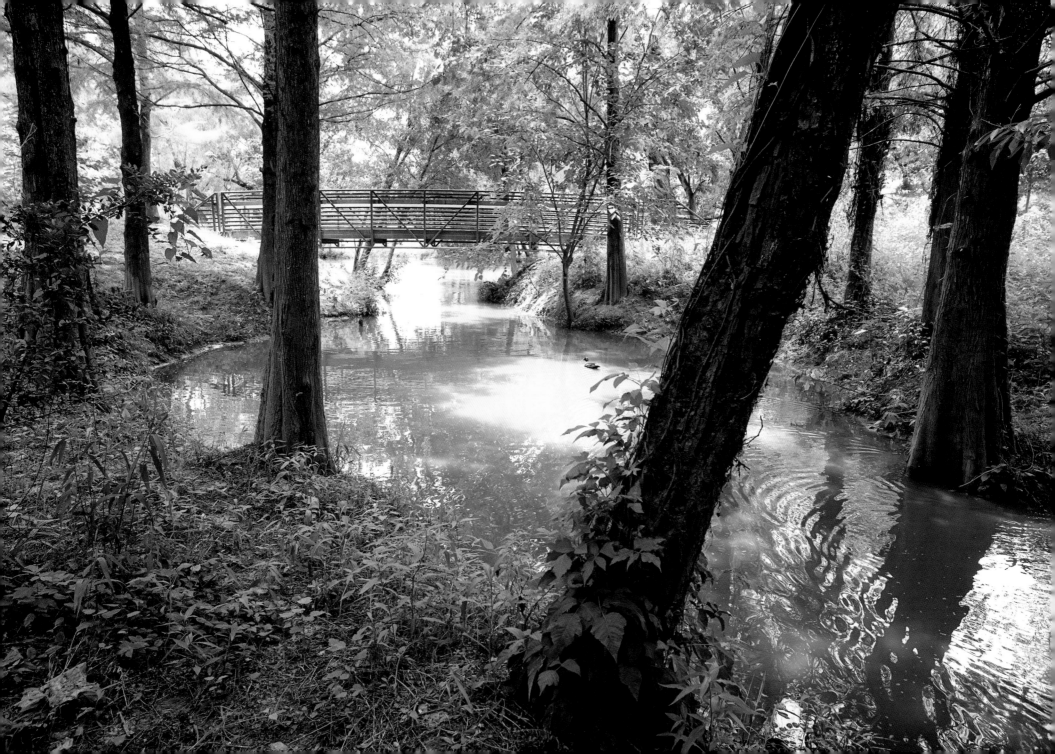

TAPLEY TRIBUTARY ③ 🔲

Just west of The Water Works area lies Tapley Tributary, a site that resembles the original landscape of the park. Exploring this thoroughly natural retreat allows visitors to experience the enduring work done by the late Houston architect and landscape architect Charles Tapley during his heroic, virtually one-man effort to transform Buffalo Bayou in the 1970s. The site, anchored by a natural tributary, features native plants and a seating area composed of granite steps. Tapley also created a small set of cascades just above the spot where the tributary flows into the bayou. A small footbridge crosses the stream, shaded by surrounding birch and cypress trees.

Tapley's plantings both beautify the area and filter water running down from the nearby Sixth Ward neighborhood, while the trees he planted continue to fortify the banks.

Upon investigation of the site, the SWA team found that the tributary's water was fairly stagnant and needed aeration. To give nature a hand, they added a fountain to gently move the water and feed it through an existing wetland area, which was enhanced with irises. "This is an example of taking something you need to do—moving water—and finding a way to bring that out into the open and celebrate it," says Scott McCready. "Plus we were able to highlight that bit of cultural history within the park."

MAKING THE ENVIRONMENT PART OF THE CITY IS THE ANSWER.

CHARLES TAPLEY

CHARLES TAPLEY
ARCHITECT AND LANSCAPE ARCHITECT

TAPLEY TRIBUTARY
Upon exploring the Tapley Tributary area of the park, visitors are often astounded at the serenity and expanse of shade and the verdant layers of foliage that make up the understory along the trails and reaching down the banks. Today, the granite steps and surrounding scene provide an enchanting outdoor learning venue. Wildlife such as turtles, fish, and birds can frequently be spotted near the waters of the tributary.

The late Charles Tapley was truly a visionary when it came to Houston's relationship to its natural setting, especially its waterways. In a 2000 interview with *Cite*, a publication of Rice University's Rice Design Alliance, he said, "No matter how nice we make the Galleria … it's never going to fully satisfy us. Making the environment part of the city is the answer. When we remove the concrete liners from the bayous, we'll have parks of such scale that [this] will naturally happen." He added, "[It won't happen] in my lifetime, but some time. Because it has to."

Tapley said this after decades of often-lonely fighting for the green development of the bayous, especially Buffalo Bayou. He actually created some of the features that enhance Buffalo Bayou Park today, and the Tapley Tributary, a section of the park cultivated to highlight a naturally occurring bayou tributary and its typical riparian flora, is named in his honor. The renovation of Buffalo Bayou Park almost happened in his lifetime, as he died just weeks before the grand opening.

④ LOST LAKE

Perhaps Buffalo Bayou Park's most scenic area is Lost Lake, located near the historic Beth Yeshurun Cemetery. The site is a welcome stop for park visitors arriving by many modes of transit: bus, car, bike, foot, and even boat. The appealing visitor center offers information, canoe and kayak rental, restrooms, breakfast and lunch service, and a private event space. Wrapping around the building is a deck, which overlooks the bayou's woodlands and exquisitely landscaped pond. The original lake, which was "lost" when a small earthen dam failed during a large flood in the 1970s, has been restored and accented by a peaceful cascade. Park visitors can be found relaxing and picnicking around the sophisticated Reed Hilderbrand–designed wetland garden that surrounds the pond and strolling at night along the lighted paths.

Photo ops abound in the Lost Lake area. Taking advantage of the beguiling outdoor setting, comprised of the flowing bayou, sloping banks, mesmerizing oak trees, and the elegantly landscaped Lost Lake itself, the commanding structure of the visitor center and The Dunlavy event space offers dramatic views from all sides and angles.

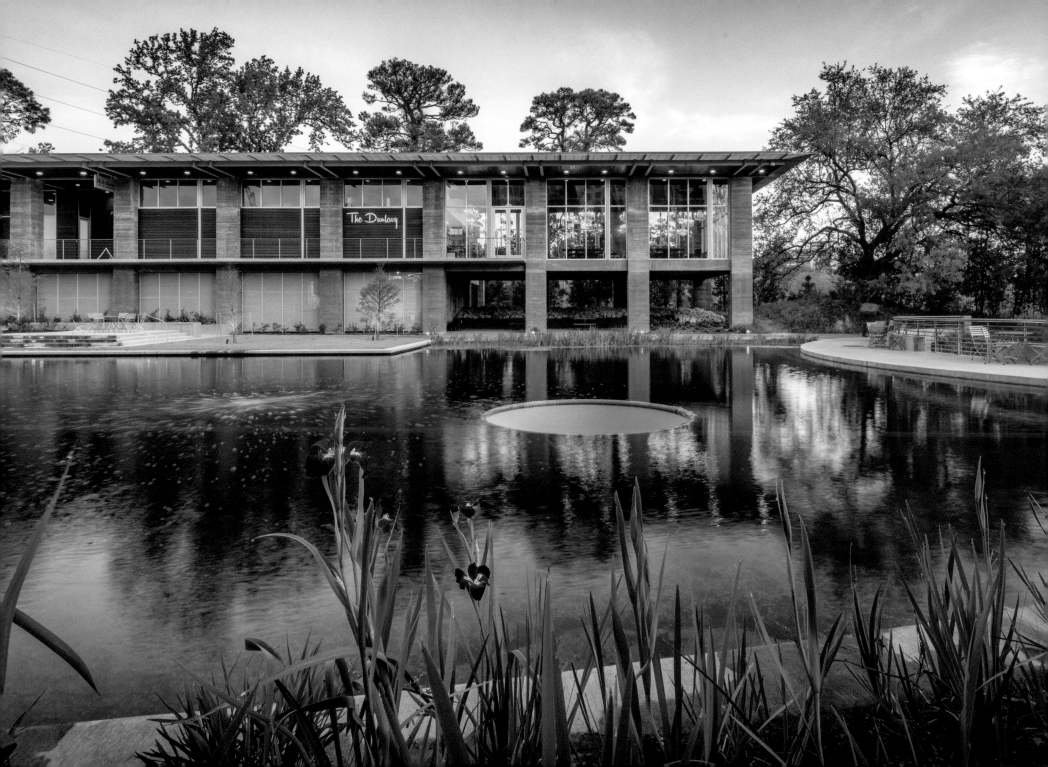

ARCHITECTURE

When Larry Speck of the firm Page began work as lead architect for Buffalo Bayou Park's structures, he faced two overarching challenges. He would have to create an architectural "vocabulary" that would link the buildings and pavilions visually, and would have to design structures strong enough to survive periodic flooding.

Speck chose Lost Lake as the laboratory to develop his formula. This particular site, established by SWA in the park's master plan, has a number of advantages. The uppermost part of the south bank sits above the floodplain, but the lower reaches of the site flood on occasion, so the area contains most of the park's various building conditions. Lost Lake enjoys several aesthetic advantages as well. It has views of the pond, views of the trees, and views of the bayou. The site is also visible from Allen Parkway, calling drivers' attention to the waterway.

When Speck began designing this first structure, he knew it would hold a visitor center and boat rental space, with the promise of additional functions in the future. Four thick board-formed concrete piers would hold such a simple initial structure. When the private event space The Dunlavy, and its connected café The Kitchen at The Dunlavy, were also situated here to take advantage of the setting, the structure grew to sixteen columns, built in a long, narrow shape that reflects the park's linear nature.

Given the cooling thermal mass of the Lost Lake Visitor Center's concrete floor and columns, and with the wall formed by the nearby bayou bank, the area beneath the building becomes a near cave, a great place to hide from the Houston summer. Cooling continues inside the structure, despite the floor-to-ceiling glass walls. Trees block the sun on the north side, while the wood ceiling, with its louvered steel blades, blocks the harshest light and creates a trellis effect inside.

Speck designed the Wortham Insurance Visitor Center at The Water Works in the same style as the Lost Lake structure. But while Lost Lake's building stretches along the bayou's bank with an emphasis on the horizontal, the Wortham Insurance Visitor Center exhibits a distinctive vertical impression. The second level was built using the same simple concrete and wood materials as the Lost Lake Visitor Center, except that it is completely open-air, thus yielding spectacular panoramic views of downtown.

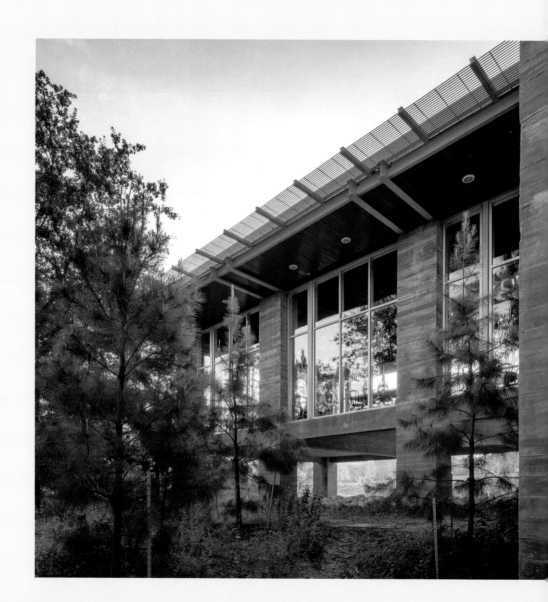

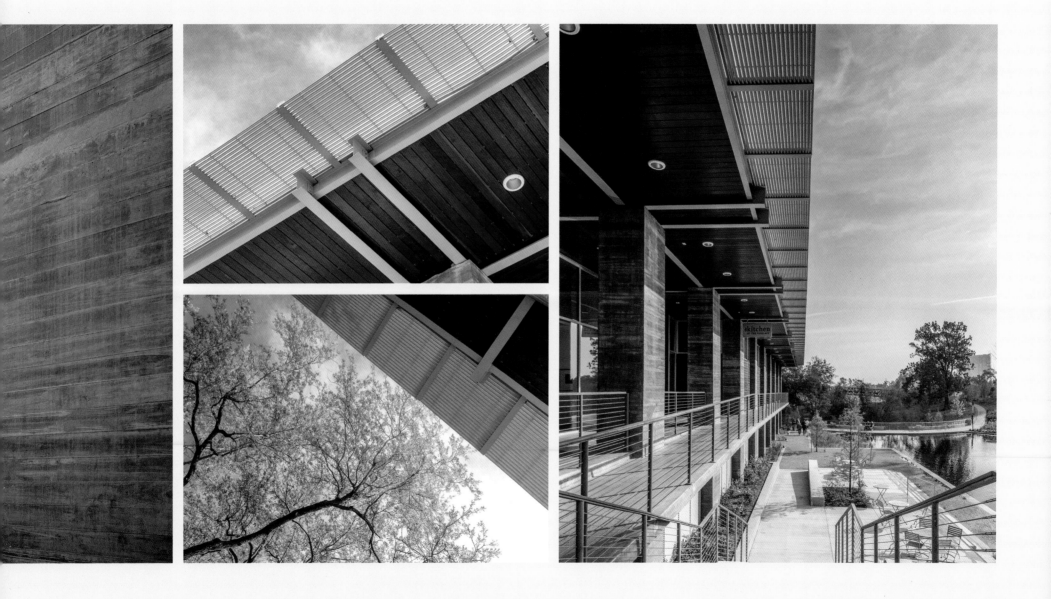

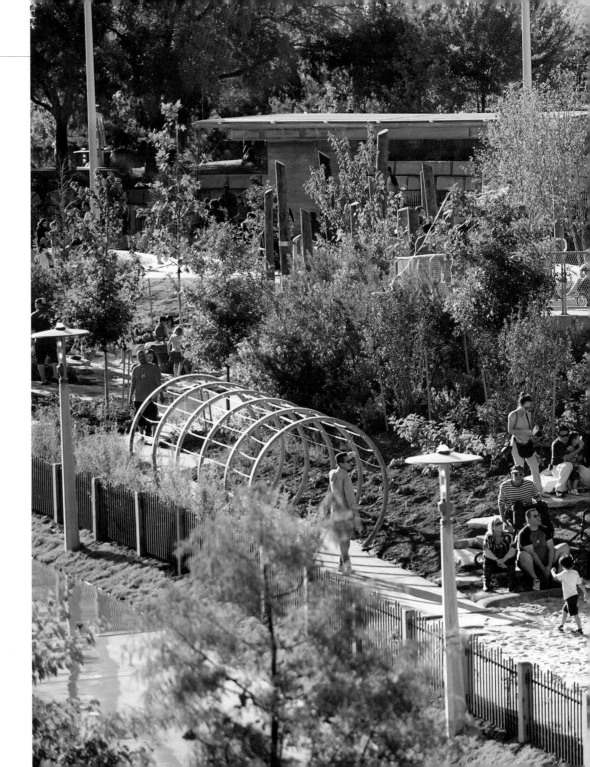

BARBARA FISH DANIEL NATURE PLAY AREA

To bring something truly special to Buffalo Bayou Park for young visitors, Buffalo Bayou Partnership and SWA approached North Carolina State University's Natural Learning Initiative. Landscape architects Robin Moore and Jesse Turner provided their expertise in designing and programming nature play and learning spaces with the goal of encouraging children to interact directly with nature.

"Studies show that children today aren't exposed to the natural world as they once were," says Moore. "This play area's natural elements help stimulate children's curiosity and connect them with nature." The curving, meandering elements of the space were inspired by the movement of water, according to Moore. Equally interesting was designing this space in a major urban center. The children of Houston do not have many playgrounds built on multiple levels, so the way the Barbara Fish Daniel Nature Play Area and Picnic Pavilion slope along the steep bank is quite a treat. The play area sports a three-tiered deck, with the surrounding area featuring boulders for climbing, a stream and waterfall, and one of the longest slides in the city.

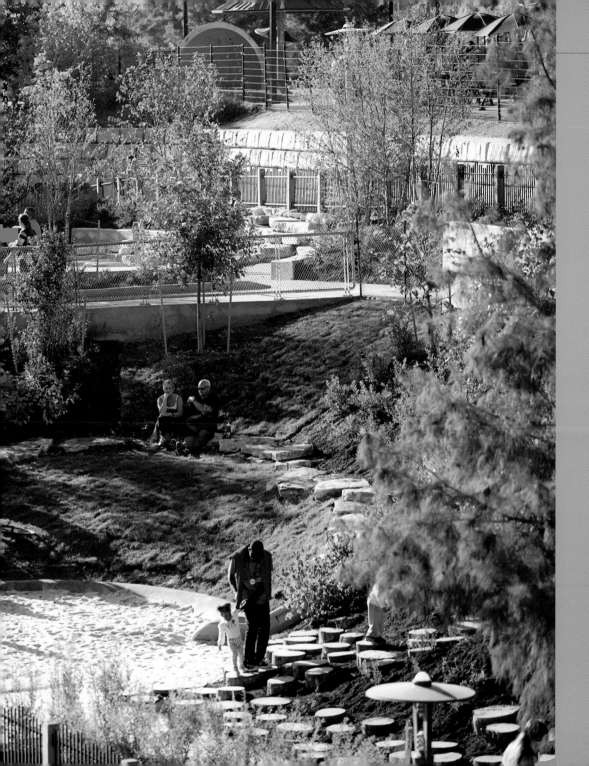

STUDIES SHOW THAT CHILDREN TODAY AREN'T EXPOSED TO THE NATURAL WORLD AS THEY ONCE WERE. THIS PLAY AREA'S NATURAL ELEMENTS HELP STIMULATE CHILDREN'S CURIOSITY AND CONNECT THEM WITH NATURE.

ROBIN MOORE, North Carolina State University Natural Learning Initiative

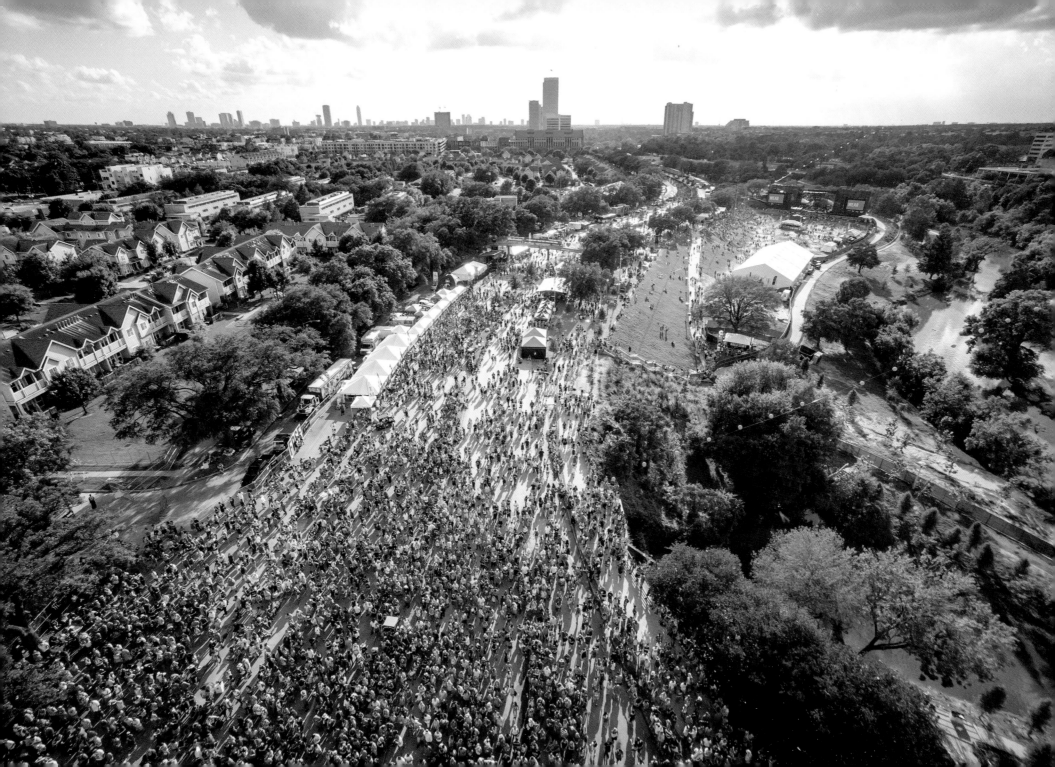

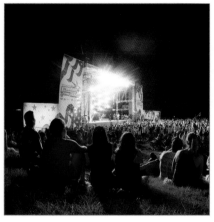

Eleanor Tinsley Park
is home to Houston's
signature Fourth
of July celebration,
Freedom Over Texas.

ELEANOR TINSLEY PARK

Buffalo Bayou Park is a park where visitors create their own, mostly personal activities. One major exception, however, is Freedom Over Texas Fourth of July festival held in Eleanor Tinsley Park, a park within a park named for the late city council member.

Eleanor Tinsley Park has been a site for civic celebrations since the 1850s, when the German community held festivals at Vauxhall Gardens at the same location. The current park was built on a section of Freedmen's Town that was sliced out of Houston's original African-American neighborhood by the construction of Buffalo Drive, now Allen Parkway. Today, the annual Freedom Over Texas Fourth of July celebration can attract up to one million people to the park and its vicinity.

The festival greatly benefits from infrastructure improvements made as part of Buffalo Bayou Park's redevelopment, including service access pathways. The open-air Nau Family Pavilion, designed from the same model and materials as the two park visitor centers, sits atop an inward bend of the bank, near the Tim Bailey sculpture *Shady Grove* that honors support groups dedicated to helping victims of crime.

JOHNNY STEELE DOG PARK

For years, the broad, low-lying area on the south bank of Buffalo Bayou between the Waugh Drive and Montrose Boulevard bridges was heavily used but was considered an informal dog park, according to City regulation. Especially on weekends, the ample space was filled with Frisbee-chasing dogs and their Frisbee-throwing owners. When Buffalo Bayou Park's redesign was announced, those owners were thrilled to see that their best friends would not be forgotten.

Named for a well-loved Houston landscape architect, the two-acre park offers a multitude of amenities for canines and their owners. Enclosed by a sturdy fence, the area is divided into sections for large and small dogs, each with its own pond. Oak trees in some portions of the park and two small pavilions provide shade as the dogs put on a show for idle spectators. With other features including benches, fountains, and washing stations, dogs may very well enjoy Buffalo Bayou Park more than anyone.

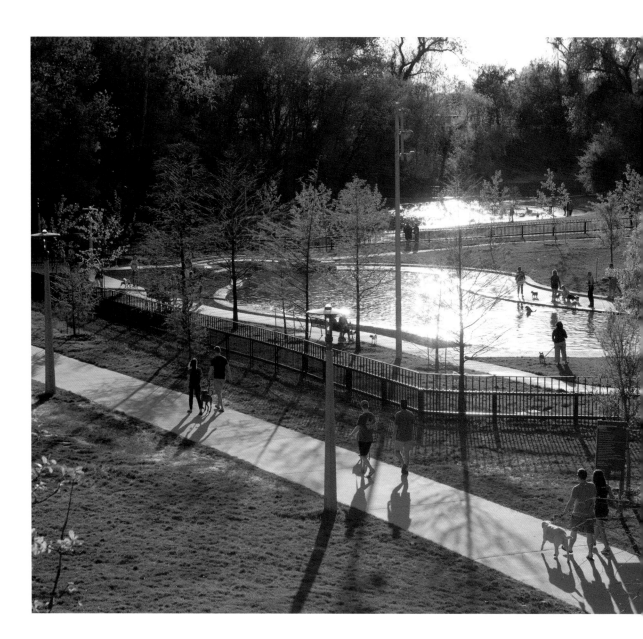

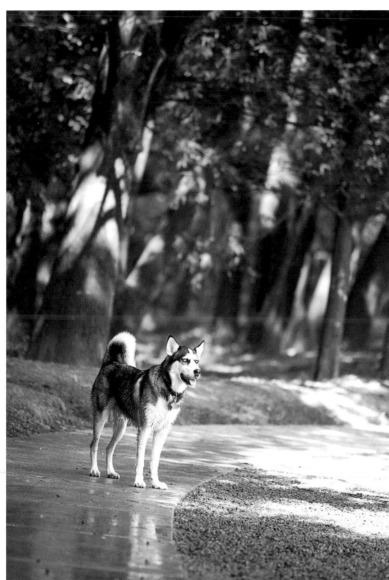

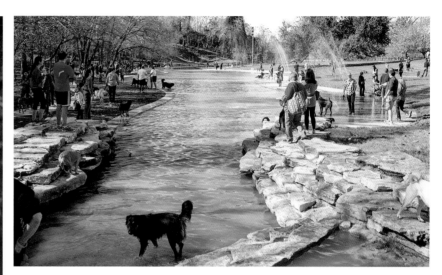

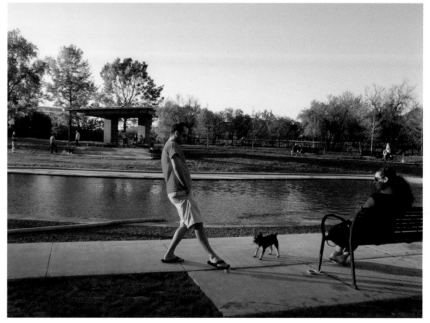

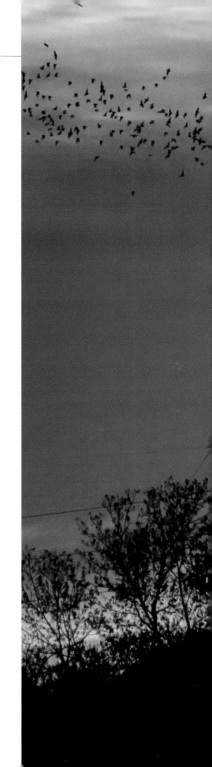

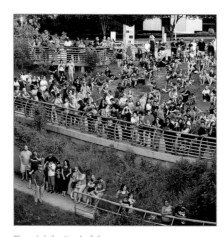

The nightly ritual of the bat colony draws crowds to observe the airborne procession of insect predators. While the winged spectacle is most abundant during warmer weather, the emergence of the bats can be witnessed year-round.

WAUGH DRIVE BRIDGE BAT COLONY

The Waugh Drive Bridge is not new. Its original structure dates from 1924, but it has a relatively new attraction: since 2003, a colony of over 250,000 Mexican free-tailed bats has taken up residence in the crevices between the bridge's concrete slabs. At sunset every day of the year, bats set out along the bayou toward downtown in search of their dinner—2.5 tons of bugs, to be exact.

Their nightly flight may not be as dramatic as the 1.5 million bats in Austin, but Houston's insect patrol has developed its own loyal following. With the increased number of visitors to Buffalo Bayou Park, bat viewing parties have grown from dozens of people to as many as two hundred a night. People arrive early to take their places on the bridge's observation deck, as well as on the Kinder Footpath below. As the bats magically emerge from their hiding places, visitors are so caught up in the experience, they do not seem to mind the ammonia odor that leaves a pungent mist in their wake.

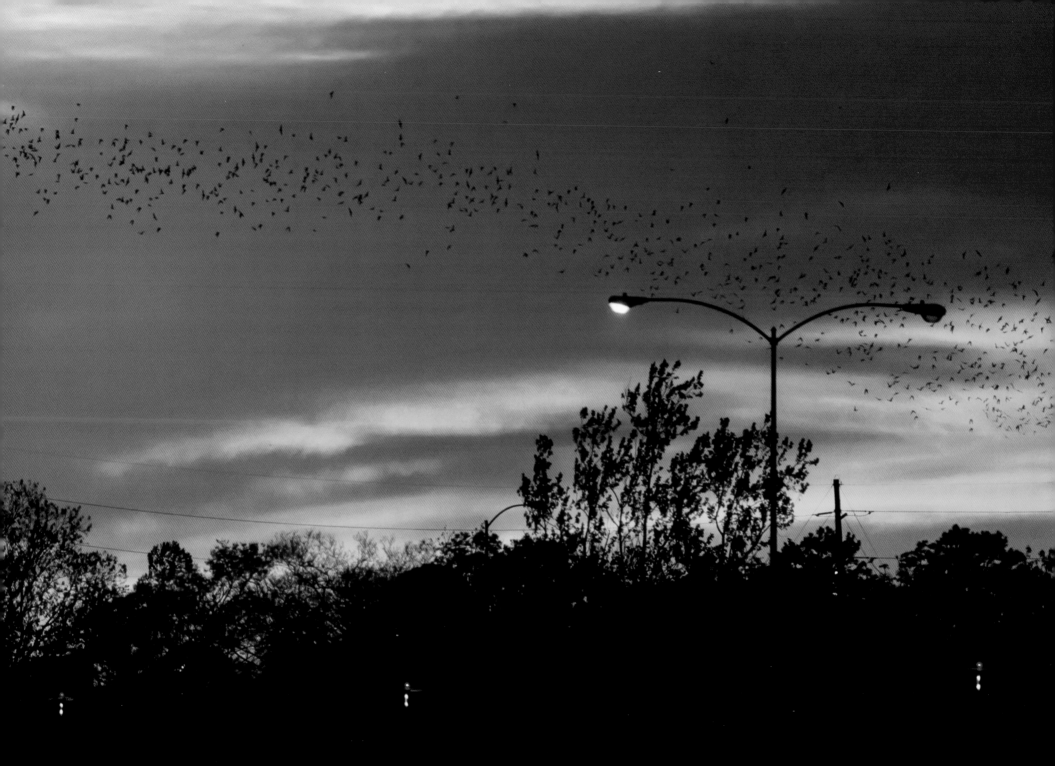

GREENSPACES CAN PROVIDE ACCESS TO ART FOR PEOPLE WHO NORMALLY DON'T FREQUENT MUSEUMS AND GALLERIES . . . PARKS ARE A SAFE, WELCOMING WAY TO VIEW ART.

JUDY NYQUIST, Buffalo Bayou Partnership Board Member and Public Art Committee Co-Chair

PUBLIC ART

Some of the park's works of art are destinations in and of
themselves, while others appear in unexpected, semi-hidden
locations, intended to surprise and delight the jogger or walker
who is momentarily converted into a patron of the arts.

1
DONALD LIPSKI'S DOWN PERISCOPE

2
JOHN RUNNELS' CANOE SCULPTURES

3
ANTHONY THOMPSON SHUMATE'S MONUMENTAL MOMENTS

4
JAUME PLENSA'S TOLERANCE

5
HENRY MOORE'S LARGE SPINDLE PIECE

6
JESÚS BAUTISTA MOROLES'
POLICE OFFICERS' MEMORIAL

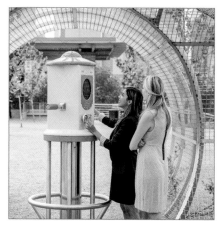

Playing on the idea of a
submarine's periscope,
Lipski's *Down Periscope*
beckons park visitors to
peek into the cavernous
Cistern, which lies beneath.

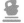 ①

DONALD LIPSKI'S
DOWN PERISCOPE

Situated on The Brown Foundation Lawn and shaded by
a vine-covered trellis is *Down Periscope* by New York
artist Donald Lipski. The artist created this irresistible
device for park visitors to peek into the mysterious
Cistern below via a moveable camera lens, which also
can be accessed and maneuvered online.

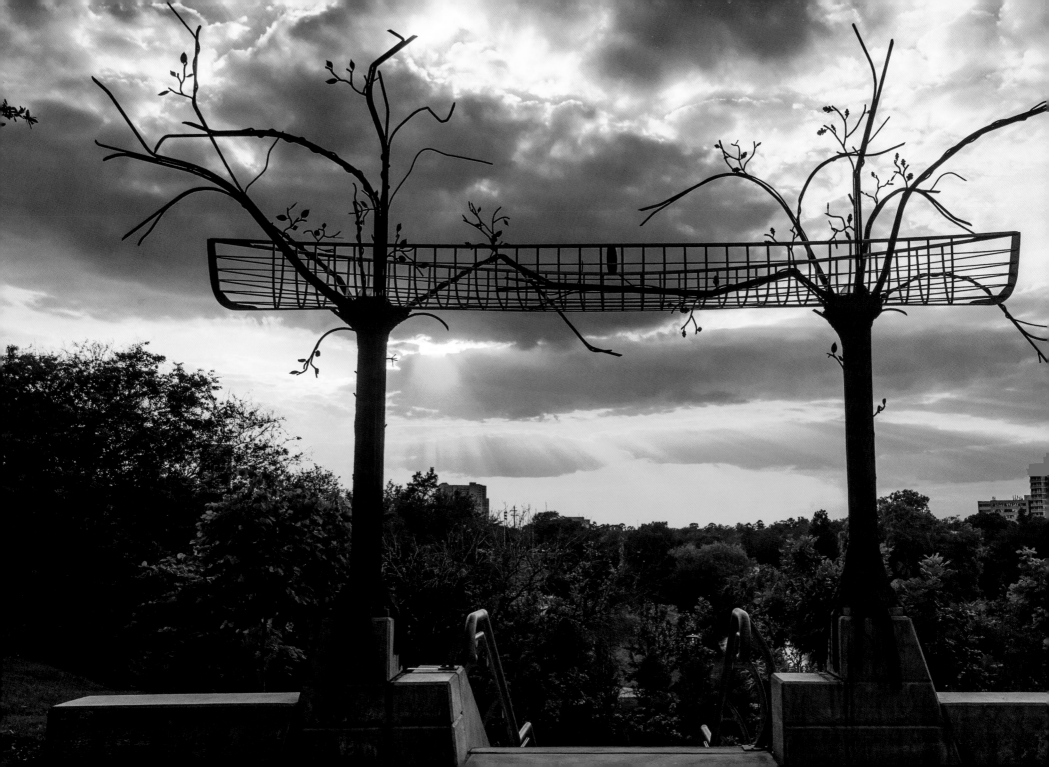

SCULPTURE NEAR SOUTH END OF SABINE STREET BRIDGE

JOHN RUNNELS' ② CANOE SCULPTURES

Houston artist John Runnels' fanciful but powerful upside-down metal boats mark key entry points along Buffalo Bayou. Inspired by the sight of leaves and feathers floating on the bayou, the artist says they reflect "Houston's most unique quality, the interpenetration of the cultural forest by the natural forest."

Making a particularly bold statement is *Portrait of Houston: It Wasn't a Dream—It Was a Flood* in Buffalo Bayou Park, located near the south end of Sabine Street Bridge. Two columns, in the form of COR-TEN metal trees, span a stair entranceway. Topping the trees, and supported by their branches, rests one of Runnels' signature canoes. Rather than bearing lines of poetry, as do many of his other boats along the bayou, this screen-like sculpture is transparent. The lightness of this effect is balanced by the heavy roots at the bases of the trees, which appear to drip like melted wax onto the entranceway.

 ③

ANTHONY THOMPSON SHUMATE'S MONUMENTAL MOMENTS

Monumental Moments, created by Houston artist Anthony Thompson Shumate, is a mixture of the whimsical and the resilient. Six words—Explore, Pause, Reflect, Listen, Emerge, and Observe—are scattered in unexpected locations along the Kinder Footpath and were designed to reflect the way people actually use the park. "People aren't going to walk up to a statue here," Shumate says. "I wanted them to be able to enjoy the artwork on the run." The evocative, four-foot-tall sculptures are anchored by stainless steel and carved from the same high-density polyethylene used to create bumpers for the massive ships that navigate the Houston Ship Channel.

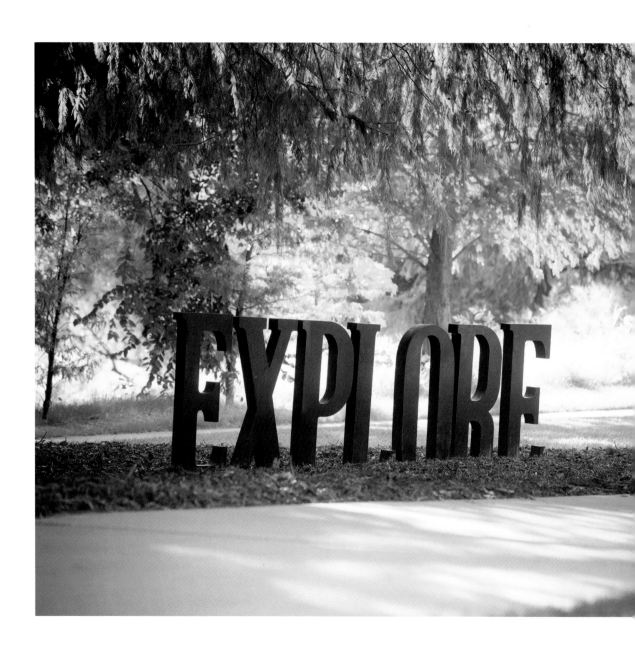

④ JAUME PLENSA'S TOLERANCE

Renowned Spanish artist Jaume Plensa applied the theme of tolerance to a set of sculptures located near the southern base of the Rosemont Bridge and shaded by oak trees. His *Tolerance* series is a set of seven 10-foot-tall kneeling figures whose bodies consist of "alphabet mesh"—stainless steel cut into letters and characters of the languages from each of the seven continents. The design allows the figures to glow from within when lit at night. Park visitors are able to closely examine the intricacy of the design and reflect on the message of the sculptures. Situated along Allen Parkway, they are impossible to miss—even from a speeding car.

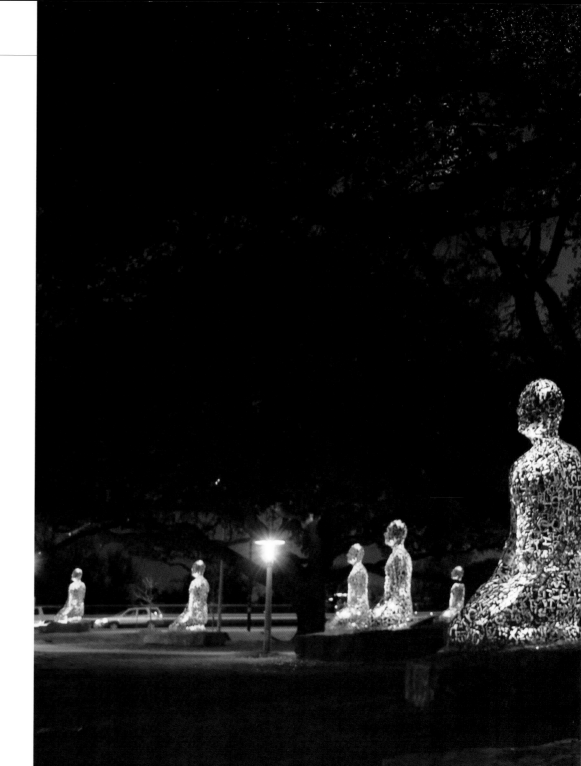

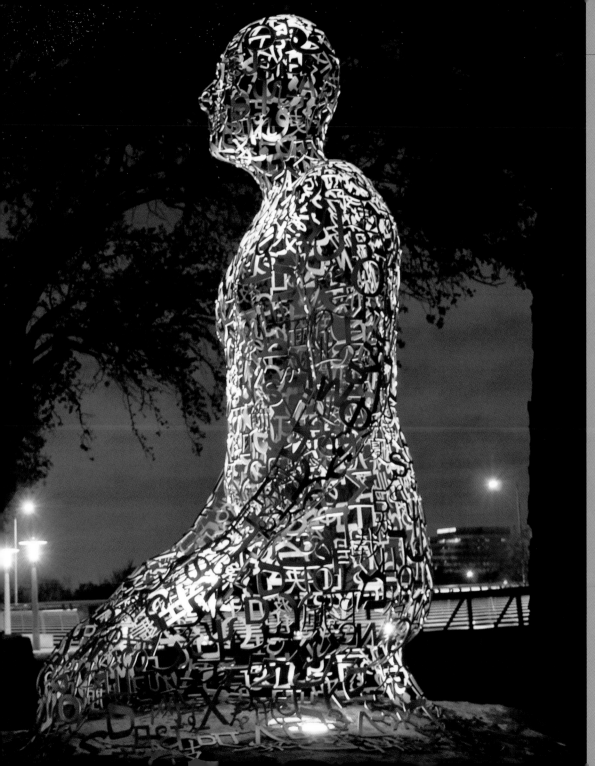

BUFFALO BAYOU IS HOUSTON'S CENTRAL PARK. WITH THE NATURE OF ITS SPACES AND TOPOGRAPHY, IT IS A MAGNIFICENT SETTING FOR ART. IT OFFERS COUNTLESS OPPORTUNITIES.

SARA KELLNER, director of civic art and design for Houston Arts Alliance

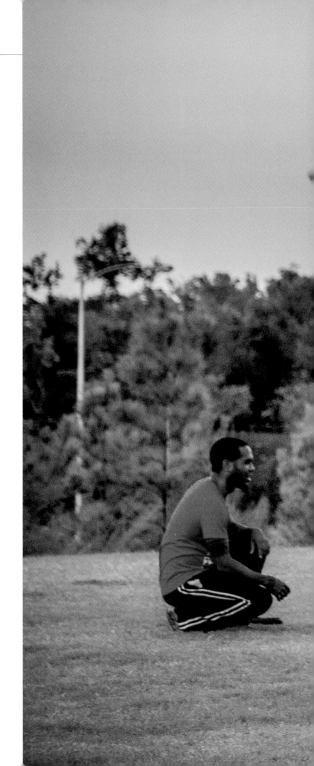

 ⑤ # HENRY MOORE'S LARGE SPINDLE PIECE

Looking at renowned English artist Henry Moore's massive abstract sculpture, *Large Spindle Piece* (created in 1969 as part of a series), across from the Federal Reserve Bank on Allen Parkway, viewers might be surprised to learn that it was inspired by Michelangelo's image of God creating man in the Sistine Chapel fresco. Moore compared the two spike-like points on the curving, 12-foot-tall, cast iron figure to the finger of God reaching down to Adam. He said, "This work is on the same theme, only the two fingers are going out, not in." Henry Moore himself travelled to Houston to locate the sculpture with architect Charles Tapley.

Today, the sculpture is flanked to the west by the formal Jane Gregory Garden, which offers benches that are ideal for pausing to contemplate the piece.

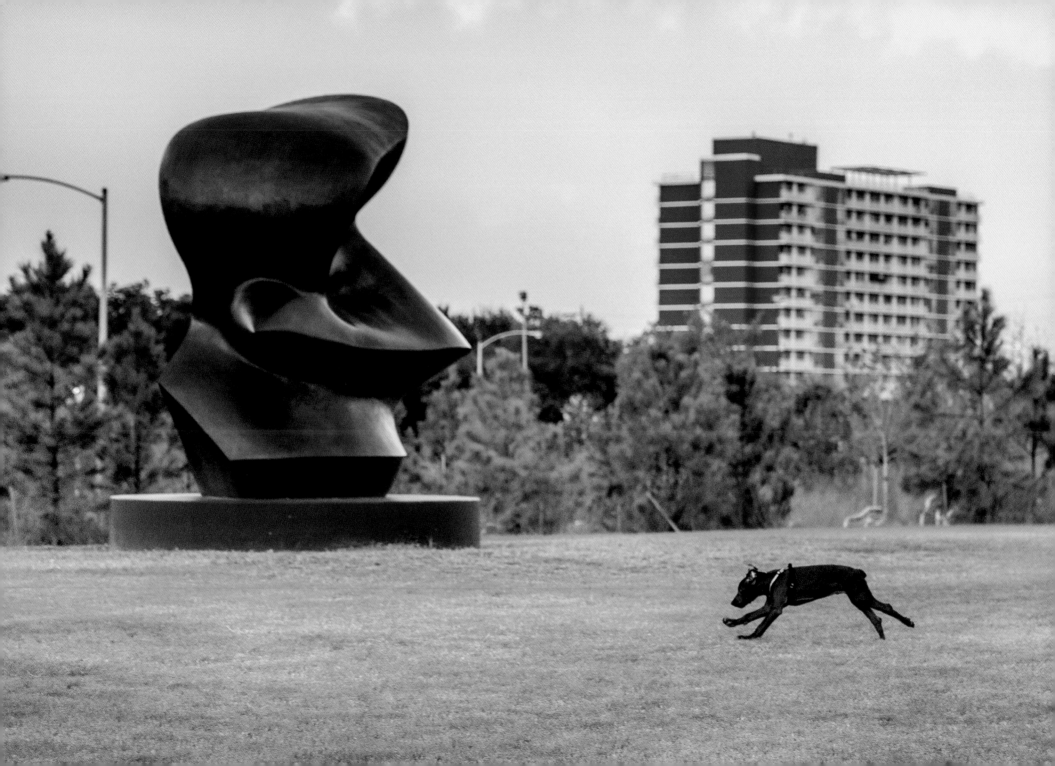

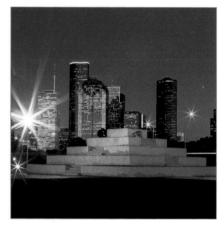

JESÚS BAUTISTA MOROLES' POLICE OFFICERS' MEMORIAL

The late Texas sculptor Jesús Bautista Moroles' monumental and rather mysterious *Police Officers' Memorial* was dedicated in 1992 and originally bore the names of 86 fallen officers, with other names added since. The structure's ziggurat, Greek cross design comprises five stepped, 40-foot-square pyramids, some rising 12.5 feet above ground level, others sunk 12 feet below ground level. Police officers maintain a permanent honor guard on the site from a nearby guardhouse.

With improved trail access via Carruth Bridge, park visitors can more easily interact with Moroles' granite sculpture, located on a significant bend in the bayou.

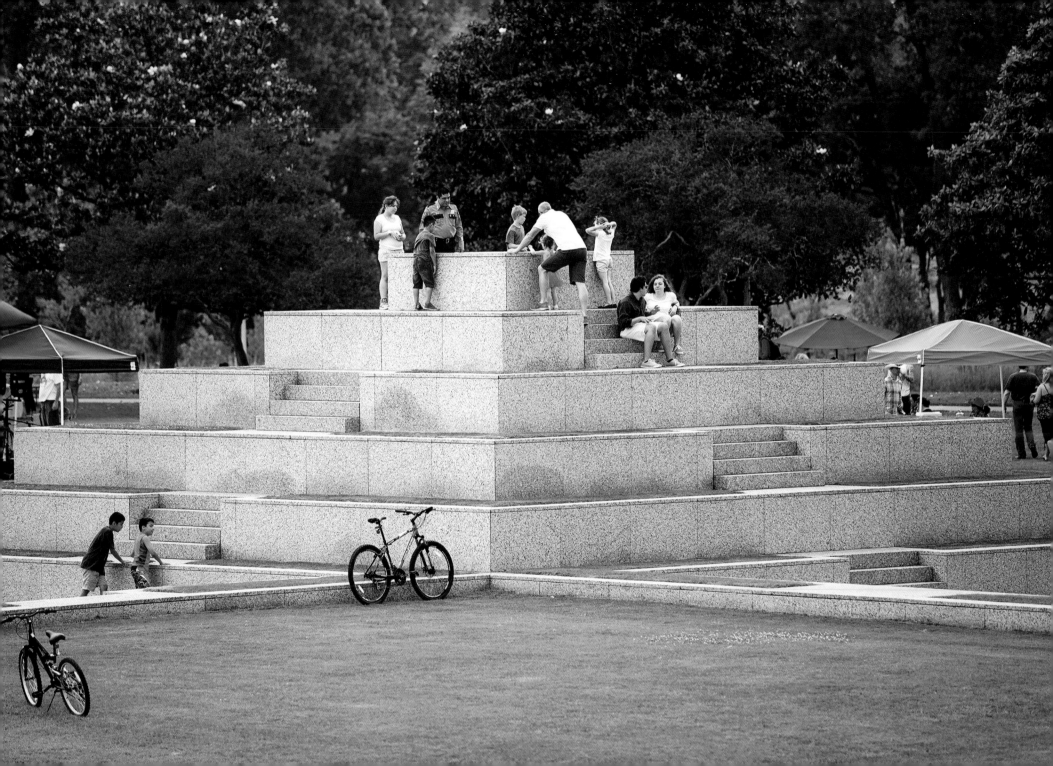

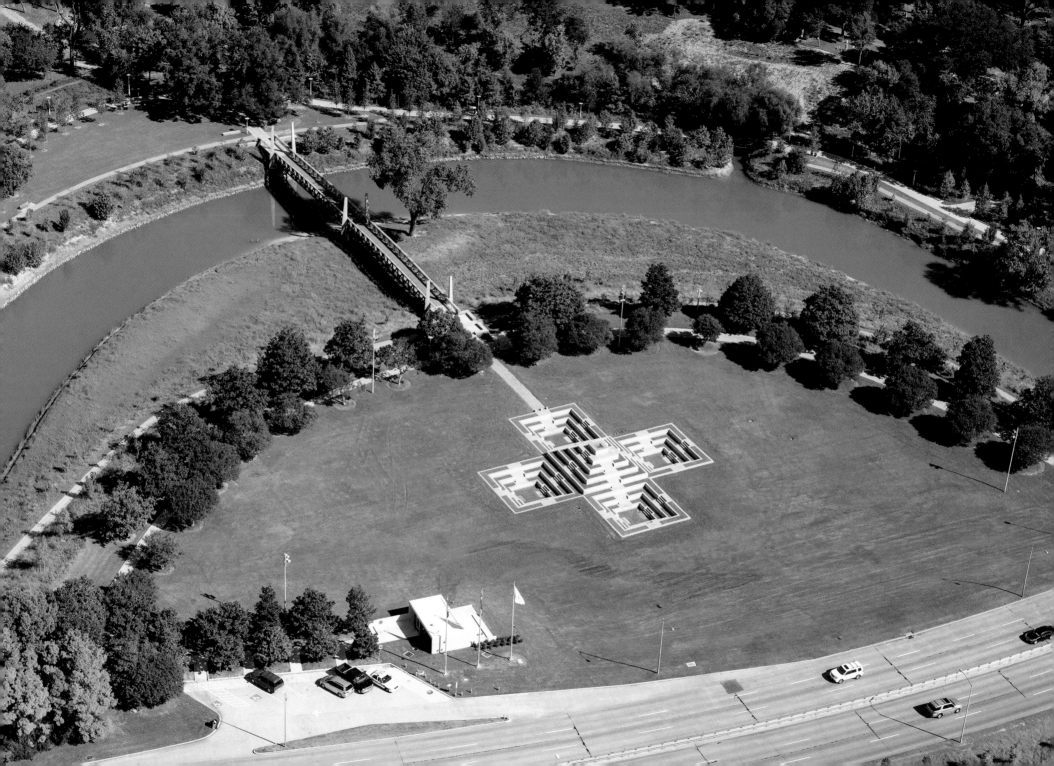

TRIBUTE
Always visible to
drivers on Memorial
Drive, pedestrians
and bicyclists found
the sculpture very
difficult to reach,
thwarting Moroles'
desire to have
visitors climb on
the pink granite
sculpture. Since
installing the Car-
ruth Bridge, which
crosses the bayou
just north of the me-
morial, the site has
become much more
accessible and a
favorite destination.
Downtown views
alone make it worth
a visit.

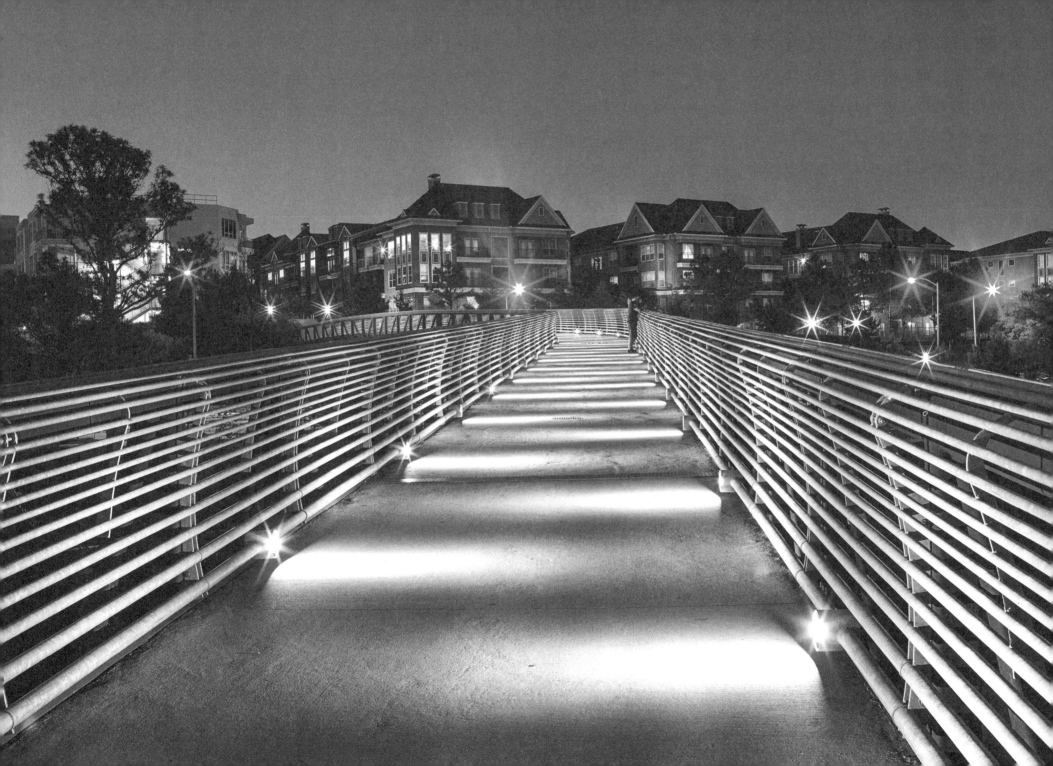

PART 5

STIMULATING DEVELOPMENT

THE BUFFALO BAYOU
DISTRICT

AMENITY

Real estate develop-
ers have embraced
the desirable areas
surrounding Buffalo
Bayou Park in great
numbers. From resi-
dential properties to
commercial mixed-
use concepts, the
park and the bayou
are now viewed
as environmental
assets rather than
hindrances.

Completion of Buffalo Bayou Park has also influenced real estate develop-ment in the vicinity. *Houston Chronicle* real estate writer Nancy Sarnoff says that in previous years, when she drove along Allen Parkway, she would be "surprised that there wasn't more development along it and Buffalo Bayou." It has always been an attractive street with ready access not only to downtown and River Oaks, which contains some of the most coveted (and expensive) residential and commercial real estate in the city, but also to the greenspace of pre-renovation Buffalo Bayou Park. "It should have been ideal for high-rises," she says.

With the park's revitalization, and the beginnings of significant real estate development along both banks of Buffalo Bayou, extending into downtown itself, Sarnoff no longer has to wonder about the lack of development. "Now developers are trying to get the name Bayou District to take off," she says. "Before, people didn't think about the bayous at all. They weren't seen as any sort of amenity. You wouldn't have seen 'bayou' being used in a name like that, not to sell million-dollar condos."

Jonathan Brinsden is CEO of Midway, a real estate company that develops distinguished residential and mixed-use properties, including west Houston's upscale CityCentre. He is a member of the Urban Land Institute (ULI) global

board of directors, as well as a former president of ULI Houston. Asked how parks in general, and Buffalo Bayou Park in particular, have influenced Mid-way's development strategies, Brinsden says, "Our company's goal is to create 'a remarkable place.' For our criteria, green or park space is fundamental. You can't have a great place without them." Brinsden calls the Buffalo Bayou Park corridor "one of the best places to invest in the entire city," and mentions that Midway is developing a 35-acre mixed-use project near the bayou.

Regent Square, a 24-acre mixed-use development, re-launched during 2016 by Boston-based GID Development, will feature 400,000 square feet of retail and restaurants, 240,000 square feet of office space, 950 multi-family housing units, and over 4,000 parking spaces. Alamo Drafthouse Cinema chain has committed to opening its first inner-loop Houston theater here. Scott McCready of SWA, who has worked on the Regent Square design, says that when the developers decided to re-start the project, they initially intended to build a block at a time, but have now decided to build a three-block critical mass at the retail and mixed-use heart of the development. McCready says, "The park increases the value and marketability of the sur-rounding lands tremendously and puts them in a more competitive place with other developments."

I THINK BUFFALO BAYOU PARK IS HAVING A HUGE IMPACT ON THE WAY AMERICA PERCEIVES HOUSTON. IT IS SEEING HOUSTON AS A WALKABLE, LIVABLE, HUMAN-ORIENTED CITY, RATHER THAN THE TRADITIONAL PERCEPTION THAT HOUSTON IS A SERIES OF FREEWAYS WITHIN THE SPRAWL.

PETER HARNIK, former director of The Trust for Public Land's Center for City Park Excellence

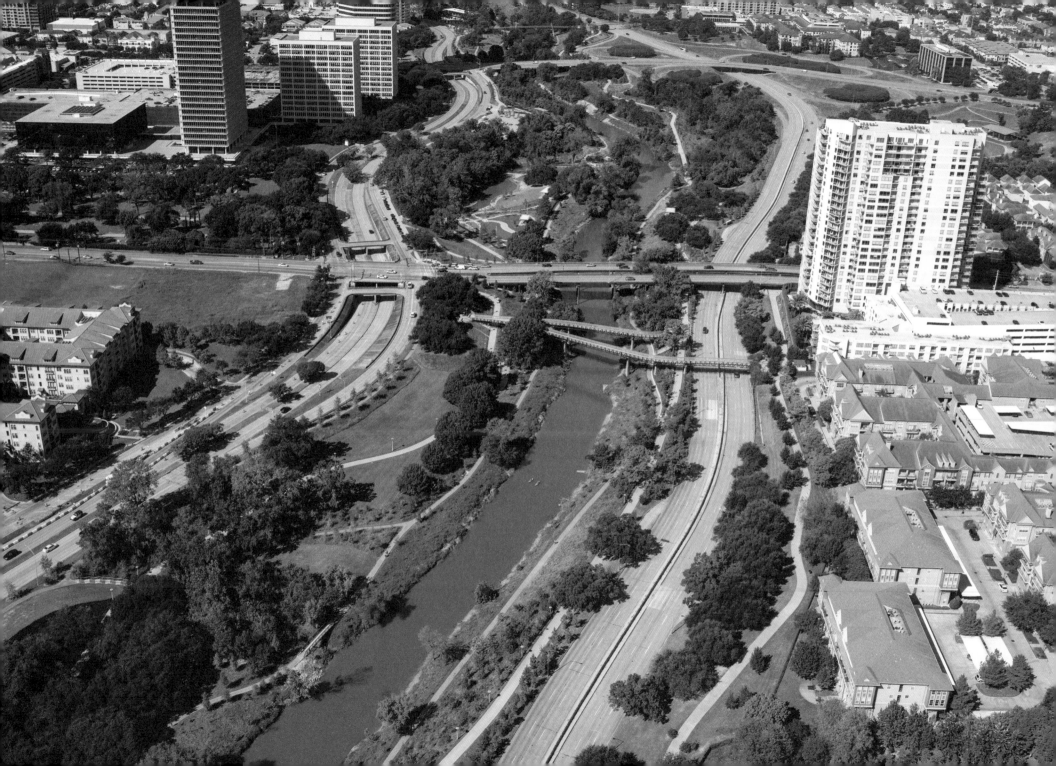

PART 6

LOOKING AHEAD

THE FUTURE
OF BUFFALO BAYOU

The creation of Buffalo Bayou Park accomplishes many objectives. It sends a message to the world about who Houstonians are, what they value, and how they do things. Most importantly, however, it tells Houstonians themselves that they are living in a new kind of city, one that matches their vision of themselves, and their dreams for themselves. And that despite the fact that this new, "green" city can seem radically different from the city of just 20 years ago, it is built on traditional Houston values.

Thanks to annual surveys that Dr. Stephen Klineberg of Rice University's Kinder Institute for Urban Research has collected since 1981, it is clear what Houstonians want from their city. Klineberg tracks the local population's thinking on a wide range of social and economic issues. His surveys consistently indicate that area residents, including those in the suburbs, crave both more greenspace and a greater sense of community.

Buffalo Bayou Park clearly addresses both of these powerful desires, but how do Buffalo Bayou Partnership's Master Plan and this renovated park speak to the city's future while drawing on its past?

For Klineberg, the creation of Buffalo Bayou Park "is a powerful indicator of the city reinventing itself for the twenty-first century." It is also a sign that Houston's "tradition of enlightened self-interest" is alive and well. "The DNA of Houston is that we do what we need to do to survive," he says. "First it was, 'How do we become a railroad hub?' Then 'How do we exploit the oil fields?' Then 'How do we create a medical center?' Then 'How can we explore space?'"

Even before the advent of railroads and automobiles, Houston initially established its port at what is now Allen's Landing in downtown Houston. Realizing its potential to become the "great interior commercial emporium of Texas" as the Allen brothers had predicted in their famous 1830s advertisement, the city later situated the Port of Houston farther east along Buffalo Bayou, closer to the Gulf of Mexico, where the 610 East Loop crosses over the bayou today. Shipping remains a robust industry for Houston, with the now 25-mile-long Port of Houston consistently ranked first in the United States in foreign waterborne tonnage, first in U.S. imports, first in U.S. export tonnage, and second in the U.S. in total tonnage.

What do any of these mighty goals have in common with beautifying a bayou or creating a park? They are all different responses to the very different times in which they were undertaken. Klineberg says, "If Houston is going [to continue] to be successful, then we will need different strategies than before oil"—before the city became the worldwide energy capital on a combination of brains and brawn.

The balance between those two attributes has shifted over the years; today we need mostly brains. Buffalo Bayou Park, among other parks and greenways that the city is creating, represents Houston's bid, in a highly competitive world, "to attract workers at the cutting edge of knowledge who can live anywhere," says Klineberg. Having these workers say, "I want to live in Houston, Texas, because of its quality of life" is central to the City's pro-growth agenda.

Looking back just a relatively few years, he says, "No one thought of the bayous as an amenity of any value. The Buffalo Bayou Park of today is a beautiful reflection of a city in a different place."

Houston has been the Magnolia City, the Bayou City, and the Space City. In its rush to the future, it has often forgotten both its past and the nature on which it was built. Sometimes we need to look back in order to move ahead. This is a challenge to our perpetual boomtown, and Buffalo Bayou Park lends evidence that we can succeed. This, perhaps, is the park's most important legacy.

ACCESSIBILITY

Buffalo Bayou and Beyond, BBP's Master Plan of 2002, promised park and greenspace development along Buffalo Bayou that would accomplish a wide range of goals, including accessibility.

In fact, accessibility was accomplished shortly after Buffalo Bayou Park was completed. In 2016, the Downtown Tax Increment Reinvestment Zone (TIRZ) #3 revamped Allen Parkway, a scenic bayou drive between Shepherd Drive and downtown. Access improvements, such as traffic signals with pedestrian crossings at Dunlavy, Taft and Gillette streets, plus a pedestrian-activated traffic signal near Park Vista Drive, were all part of the reconfiguration. The design also includes landscaped medians and reduced speed limits to tame automobile traffic, as well as close to 150 parking spaces adjacent to Buffalo Bayou Park that buffer park users from the roadway's traffic.

The many stately live oaks along Allen Parkway's south side were reinforced with additional oaks. SWA's team also wanted the streetscape to be in concert with the landscape of Buffalo Bayou Park. For the medians on Allen Parkway, airy Mexican sycamores were selected rather than dense live oaks to maintain the view of the downtown skyline and the park to the north—such an important vista.

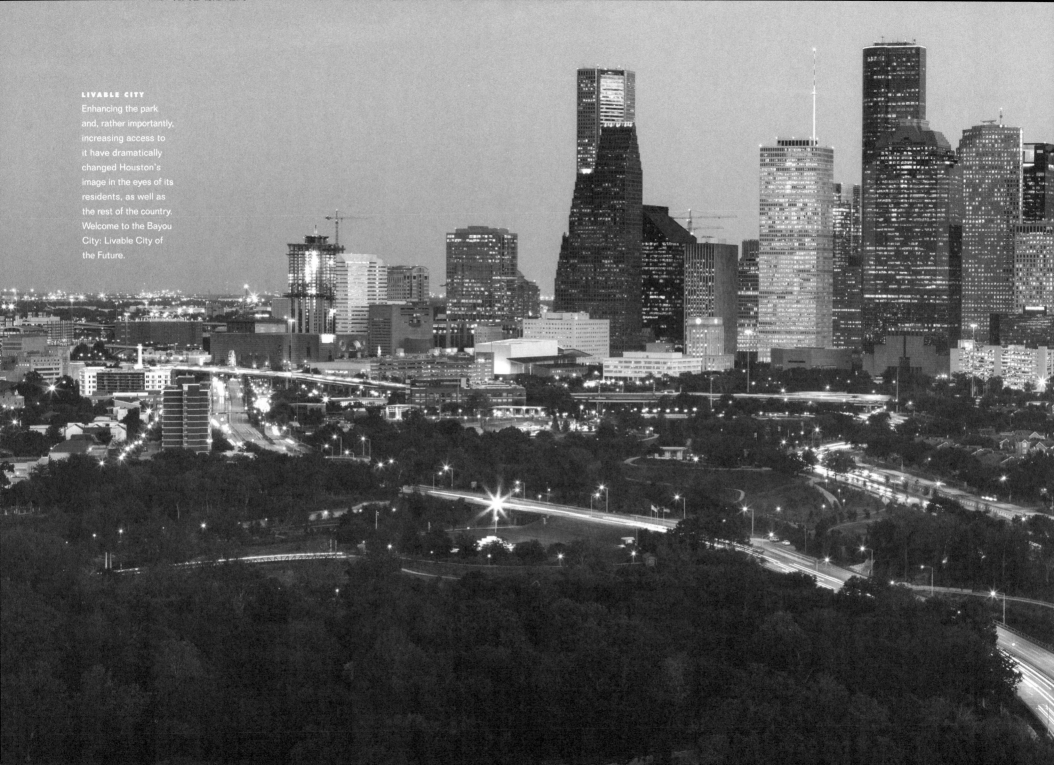

LIVABLE CITY
Enhancing the park and, rather importantly, increasing access to it have dramatically changed Houston's image in the eyes of its residents, as well as the rest of the country. Welcome to the Bayou City: Livable City of the Future.

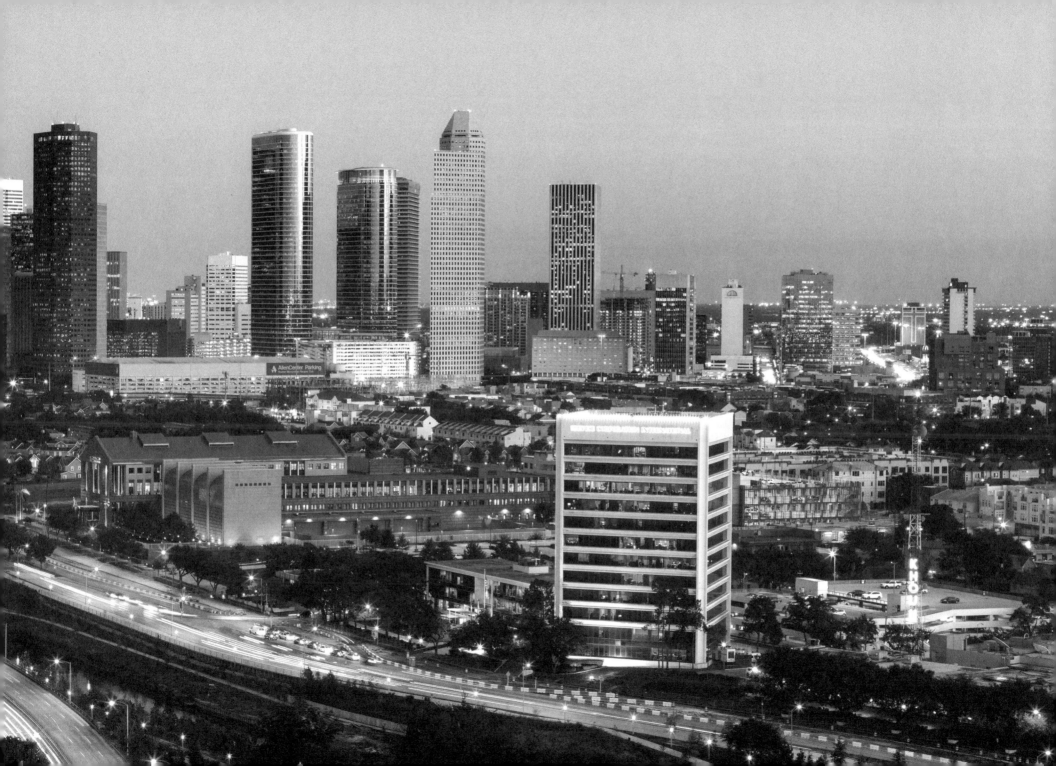

AFTERWORD

BUFFALO BAYOU PARK IS TRULY A TESTAMENT TO THE TRANSFORMATIVE ROLE THAT GREENSPACE CAN PLAY IN A TWENTY-FIRST-CENTURY CITY.

BY

**ANNE OLSON,
BUFFALO BAYOU
PARTNERSHIP
PRESIDENT**

The park has breathed new life into a long-forgotten and neglected area, and, most importantly, changed how Houstonians from all walks of life feel about and view their city. It also has generated significant media attention, not just locally, but nationally and internationally. In addition, it is proving to be a strong economic driver, stimulating significant development in adjacent neighborhoods, and helping attract and retain the coveted knowledge workers so important to a region's prosperity.

Buffalo Bayou Park symbolizes the civic will of Houston's people. From early visionaries like Terry Hershey and Charles Tapley, to Buffalo Bayou Partnership board members and staff, past and present, to catalyst funders Rich and Nancy Kinder, to governmental leaders like former Mayor Annise Parker who have worked alongside Buffalo Bayou Partnership for decades, and to the thousands of citizens who have shared their ideas and expertise—all have played a vital role in making the park what it is today.

The same commitment, hard work, and financial support that have made Buffalo Bayou Park a reality will be needed in the years ahead. Due to the City of Houston's strong support, the Downtown Tax Increment Reinvestment Zone (TIRZ) #3 is providing long-term funding for the park's maintenance and operations. Volunteers are essential to supplement the work of park staff. Whether pulling weeds or removing invasive vines, volunteers are key to maintaining the park's beauty and protecting its unique ecology.

Building upon the enormous success of the park, other BBP projects such as the restoration of historic Allen's Landing, and the city's incredible open space renaissance, BBP now is looking east of downtown, where it has been making incremental improvements for decades. What awaits is a waterway with a distinctly different character that holds just as much promise. Through a recent planning effort, BBP has developed a comprehensive list of goals and recommended projects, as well as a clear framework for future funding of land acquisition, hike and bike trails, and other capital projects.

Similar to Buffalo Bayou Park, a strong public-private partnership with the City of Houston and Harris County, a wide range of funding from foundations, corporations, and individuals, and a strong volunteer base will all be necessary to move Buffalo Bayou Partnership's east sector enhancement program forward. We are confident that Houstonians will remain committed to helping us create transformative greenspace projects that will provide sustainability, accessibility, and improved quality of life for all Houston citizens. We look forward to continuing our journey with you!

DONORS

From Rendering to Reality: The Story of Buffalo Bayou Park was generously underwritten by the Kinder Foundation.

The $58 million Buffalo Bayou Park project was a public-private partnership led by Buffalo Bayou Partnership, City of Houston through the Houston Parks and Recreation Department, Harris County Flood Control District, and the Kinder Foundation.

The Kinder Foundation provided catalyst funding of $30 million in 2010, an unprecedented gift to Houston's park system. Buffalo Bayou Partnership raised an additional $23.5 million for the project and oversaw the design and construction. Buffalo Bayou Partnership maintains and operates the park with funding of $2 million per year provided by the Downtown Tax Increment Reinvestment Zone (TIRZ) #3.

Buffalo Bayou Partnership sincerely thanks all of the generous individuals, foundations, corporations, and partners who made Buffalo Bayou Park a reality.

Buffalo Bayou Park

Kinder Foundation

The Brown Foundation, Inc.
Downtown Tax Increment Reinvestment Zone (TIRZ) #3
Harris County Flood Control District
Houston Endowment Inc.
Silver Eagle Distributors, L.P.
The Wortham Foundation, Inc.

The Carruth Foundation, Inc.
The Cullen Foundation
Ray C. Fish Foundation
The Fondren Foundation
Hobby, Beckworth and Gibson Families

Apache Corporation
Karol and Paul F. Barnhart Jr.
Polly and Murry Bowden
Zane and Brady Carruth
Dan L Duncan Family
John R. Eckel, Jr. Foundation
The Elkins Foundation
Cherie and Jim Flores
The Garden Club of Houston
Bob and Annie Graham Family
H-E-B
Hildebrand Foundation
Hines
Houston Chronicle
KHOU 11
Meredith and Cornelia Long
Kathrine G. and John P. McGovern
Janice and Robert C. McNair

Petrello Family Foundation
Wilhelmina E. "Beth" Robertson
Scurlock Foundation
The Virginia and L.E. Simmons Family Foundation/United Airlines
Judy and Charles Tate
Susan Vaughan Foundation
David and Mary Wolff Family
Wortham Insurance

ACE Group
Stanford and Joan Alexander Family
Chinhui Juhn and Edward R. Allen III
American International Group, Inc.
M.D. Anderson Foundation
BBVA Compass
The Brown Foundation, Inc./ Nancy Abendshein
CNA Insurance
Chubb Group of Insurance Companies
Kelty and Rogers Crain
Crane Foundation
Virginia Hoops and Thomas Lee Doggett
Marcia and Michael Feldman
GID Development
The Hamill Foundation
Ann Lents and David Heaney
Albert and Ethel Herzstein Charitable Foundation
Sis and Hasty Johnson
Liberty Mutual Insurance
Mithoff Family Foundation
Bill and Sara Morgan
The Powell Foundation
Radoff Family
River Oaks Garden Club

Sterling-Turner Foundation
Texas Mutual Insurance Company
The Vale-Asche Foundation
Zurich North America

Albert and Margaret Alkek Foundation
Bank of America Merrill Lynch
Susan and Ron Blankenship
BlueCross BlueShield
Brookfield
The Gordon A. Cain Foundation
Vivien and Scott Caven
The Clayton Fund
Ann Marie and Mark Cover
Clayton and Shel Erikson
Richard and Patti Everett
Nijad and Zeina Fares
Jerry and Nanette Finger Family Foundation
Susan and Mike Garver
Cathy, Reggie and Allison Guettner
Guy Hagstette
The Hastings Family Fund
Diana and Russell Hawkins
Linda and Barry Hunsaker
Ironshore Insurance Services LLC
Light Charitable Trust
Locke Lord LLP and The Kayser Foundation
Stephen L. Madden
Melcher Charitable Foundation
Ellen S. and William D. Morris
Tim and Roxann Neumann
Beverly and Staman Ogilvie
Robin Reed
The Family of Joe and Anne Romano
Leslie and Shannon Sasser
Mary Eliza and Park Shaper

Vivian L. Smith Foundation
Strake Foundation
Transwestern
The Travelers Companies, Inc.
Eugene H. and Susan W. Vaughan Family
Leslye and David Weaver
Meg and Dick Weekley
The West Endowment
Whole Foods Market
Lorraine and Ed Wulfe

Neelofur and Sami Ahmad
Julie and Andrew M. Alexander
Andrews Kurth LLP
Mark S. Antonvich
Terri Lacy and Jim Baird
Dana and Ronald Bankston
Karen and Charlie Baughn
Linda Cizek Skinner Brown
The Brown Foundation, Inc./Andrew Abendshein
The Brown Foundation, Inc./Nancy O'Connor
Harry S & Isabel C Cameron Foundation
Central Houston Civic Improvement
Barbara K. Chiles
Don Clement
Jacquelyn and Collin Cox
John Cryer, III/PageSoutherlandPage
Rebecca Dalton
Kelly Dehay and Rod Danielson
The Honorable and Mrs. Edward P. Djerejian
Jennifer and Steve Dolman
Kathryn and Gary Dudley
Felvis Foundation/David Graham
Amanda and Thatcher Focke
Lisa Foronda
Patrick G. Grant

The Hanover Insurance Group

Houston Architecture Foundation

Marie and Edward Kaminski

Melissa and Steven Kean

Matt and Carolyn Khourie

Meredith and Harry Lamberton

The Lionstone Group

Anne Marie Ruszkowski and Michael Lord

Christiana and John Luke McConn, III

Mr. and Mrs. Rick McCord and Family

Chrissi and Mike Morgan Fund

Louise S. Neuhaus

Ralph E. and Michaelene Lusk Norton

Judy and Scott Nyquist

Charles R. and Diane P. Ofner

The Robert R. and Kay M. Onstead Foundation

Cynthia L. and Mark J. Ormson/Lu Quast
 Memorial Bench Fund

Alvin and Lucy Owsley Foundation

Charlie and Marsha Parker

Elena and Jeff Peden

Mr. and Mrs. Robert W. Phillips

Regent Square developed by GID

Winifred and Carleton Riser

SPJST Lodge 88

Howard and Karen Schneider

Colleen Sherlock

Ellen Simmons

Jane and Kenneth Valach

Yvonne R. Victery

Lisa and Craig Wilson Family

Bill and Marie Wise

Geraldina I. and Scott W. Wise

Sallie and Bob Wright

Aceca LLC DBA Cuchara

The Allshouse Group LLC

Kim and Ian Anderson

Nory Angel

Jeffrey R. Armstrong

Mr. and Mrs. Isaac Arnold, Jr.

Louise and Thomas Bannigan

Richard T. Bradley

Larry & Katherine Buck Fund

Carol and Bill Butler

Paul Cannings Jr. - RPH Consulting Group

Cathy and Paul Chapman

Mitch and Libby Cheney

Chevron Humankind Matching Gift Program

Angie and Aaron Clark

Carolynn H. and Michael Connelly

Allyson and Steve Cook

Carolyn and Doug Corbett

Susan Elmore/Elmore P.R.

Jean and Erik Eriksson

Shari and Thomas Fish

D.V. (Sonny) Flores

William V. Flores

Cheryl and Andrew Fossler

Harriet and Joe Foster

Debby Wandel Francis

John G. Garza

Kate and Steve Gibson

Mr. and Mrs. Charles H. Gregory

Melissa and Albert Grobmyer/Puffer-Sweiven

Harris County Medical Society Alliance

Gerald D. Higdon

Houston Arts Alliance

Houston Wilderness

Lynne and Wayne Johnson

Laura and Steve Jones

Susan Keeton

Marie Louise and David Kinder Fund

Josh Kirklin

LESCO Architectural Lighting

Kathleen and Randall Lake

Sherman L. Lewis III/Lewis Group LLP

Antoinette and Joseph Listengart

Susan and David Lummis

Stephanie Macey

Stephen Massad

Edward C. Bajorek and Mary Ann McCulley

John McLaughlin

Mayes and Macy Middleton

Kelly and John Mooz

Newfield Exploration Company

Anne and Tom Olson

Adrian Patterson

Susie and Daron Peschel

Larry A. Peterson

Shelly B. and Martin J. Power

Edna Ramos

Susan and Barrett H. Reasoner

Rivera Family

Kim and David Ruth

Margaret and Joel Shannon

Shell Oil Company Foundation Matching
 Gifts Program

Barbara and Louis Sklar

Smith Murdaugh Little & Bonham LLP

Bob and Marty Stein

James E. Street

Anne and Taft Symonds

Jeff Taylor

J.A. Turner

Timothy John Unger

John E. Walsh, Jr.

Debra Witges

Margaret and Jerry Wolfe

Ellyn Wulfe

Buffalo Bayou Park Cistern

The Brown Foundation, Inc.

Donors of $1,000+
As of May 1, 2016

*Every effort was made to ensure that the
information published is accurate and
reflects the requests of individual donors.
If any inadvertent errors or omissions have
occurred, please notify Buffalo Bayou
Partnership's Director of Development.*

CREDITS

Photographs | **Zahid Alibhi**
pgs. 90-91
Jenny Antill
pgs. 67, 69 (left)
Nash Baker
pgs. 84
Katya Horner
pgs. 18, 30-31, 35, 36, 42 (bottom left, right), 44-45, 46-47 (middle),
55 (right), 60 (right), 62-63, 65, 66, 74-75, 79 (middle, top right), 80,
81, 85, 86-87, 88, 89 (middle), 92-93, 95, 98
Geoff Lyon
pg. 57
Peter Molick
pgs. 64 (courtesy of Magdalena Fernández and Sicardi Gallery), 76
Jim Olive
cover, pgs. 15, 16, 21, 26-27, 28-29, 31, 34, 37, 40-41, 42 (top left),
46 (left), 47 (right), 48-49, 52-53, 54 (left), 69 (right), 77, 78, 79
(bottom right), 94, 96, 101, 103, 104-105
John Runnels
pg. 13
Karen Sacher
pg. 19
Jonnu Singleton
pg. 89 (right)
Brian Swett
pg. 7
Slyworks Photography
pgs. 60 (left), 61, 70, 71, 72, 73

Renderings | **Thompson Design Group**
pgs. 10,12

Reed Hilderbrand
pgs. 22-23, 25, 26, 28, 31, 35, 36, 39, 51, 59, 83

Illustrations | *Special section: A Guide to the Birds
and Plants of Buffalo Bayou Park*

Birds
All bird illustrations originally published in A FIELD GUIDE TO THE
BIRDS OF TEXAS by Roger Tory Peterson. ©1960, 1963 by Roger
Tory Peterson. Reprinted with permission of Houghton Mifflin
Harcourt Publishing Company. All rights reserved.

Wildflowers
1, 6, Harvard University Botany Libraries; 2, 4, 5, 7, Peter H. Raven
Library/Missouri Botanical Garden; 3, New York Botanical Garden;
8, Smithsonian Institute; 9, Natural History Museum, London.

Trees
1, New York Botanical Garden; 2-3, 5-6, Peter H. Raven Library/
Missouri Botanical Garden; 7, Smithsonian Institute, Biodiversity
Heritage Library.

Grasses and Shrubs
1-2, 6, Peter H. Raven Library/Missouri Botanical Garden; 3-4, 7-8, U.S.
Department of Agriculture, National Agricultural Library; 5, courtesy
University of Illinois Urbana-Champaign.

First edition

ISBN 978-1-62349-610-4

The Library of Congress Cataloging-in-Publication Data are on file at the Library of Congress.

Book design by Carla Delgado, Julie Savasky, and DJ Stout, Pentagram Design, Austin, Texas

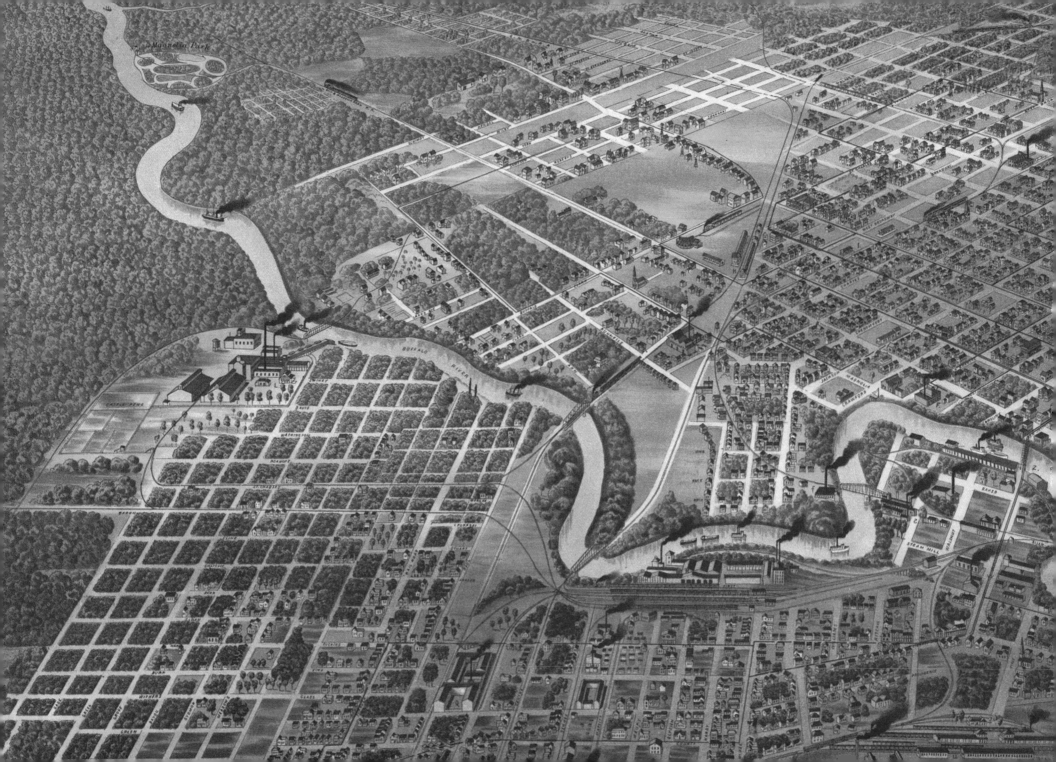